THE SKETCH

ROBERT S. OLIVER

 VAN NOSTRAND REINHOLD COMPANY

NEW YORK CINCINNATI ATLANTA DALLAS SAN FRANCISCO
LONDON TORONTO MELBOURNE

DEDICATED TO MY WIFE....

VAN NOSTRAND REINHOLD COMPANY REGIONAL OFFICES:
NEW YORK CINCINNATI ATLANTA DALLAS SAN FRANCISCO

VAN NOSTRAND REINHOLD COMPANY INTERNATIONAL OFFICES:
LONDON TORONTO MELBOURNE

COPYRIGHT © 1979 BY LITTON EDUCATIONAL PUBLISHING, INC.

LIBRARY OF CONGRESS CATALOG CARD NUMBER: 79-16105
ISBN: 0-442-26249-3 PBK
ISBN: 0-442-25659-0

MANUFACTURED IN THE UNITED STATES OF AMERICA

PUBLISHED BY VAN NOSTRAND REINHOLD COMPANY
135 WEST 50TH STREET, NEW YORK, N.Y. 10020

PUBLISHED SIMULTANEOUSLY IN CANADA BY VAN NOSTRAND REINHOLD LTD.

15 14 13 12 11 10 9 8 7 6 5 4

LIBRARY OF CONGRESS CATALOGING IN PUBLICATION DATA

OLIVER, ROBERT S 1919 -
 THE SKETCH.

 BIBLIOGRAPHY: P 129
 INCLUDES INDEX.
 1. DRAWING--INSTRUCTION I. TITLE.
NC 795.05 741.2 79-16105
ISBN 0-442-26249-3 PBK
ISBN 0-442-25659-0

TABLE OF CONTENTS

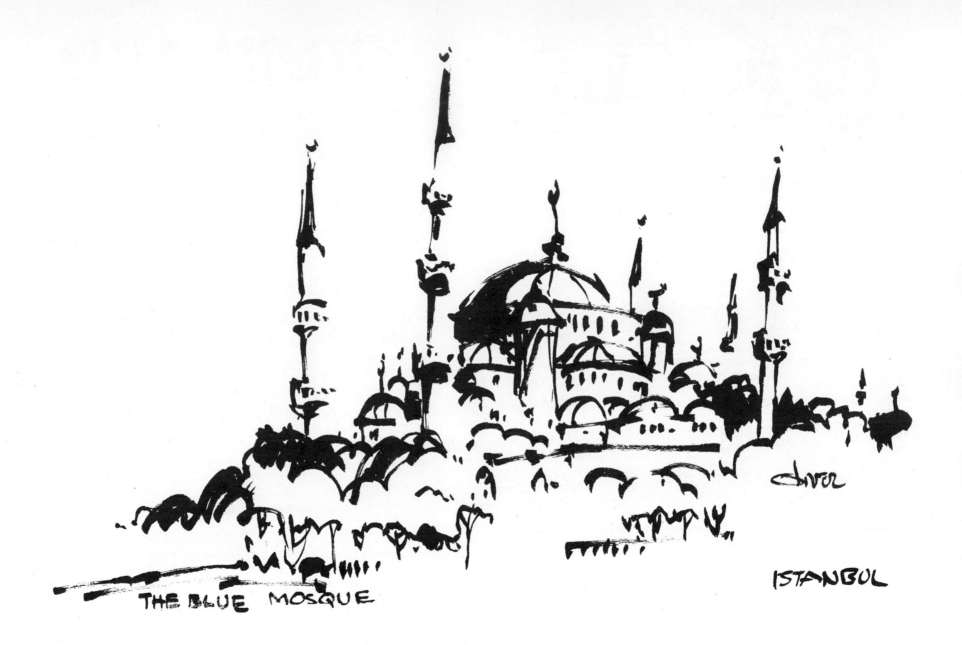

THE BLUE MOSQUE

ISTANBUL

4

FOREWORD

THE SKETCH IS A GRAPHIC MEANS FOR RECORDING AND COMMUNICATING A VISUAL EXPERIENCE OR MENTAL IMAGE. TO BE ABLE TO DO THIS QUICKLY AND EFFECTIVELY IS AN INVALUABLE TOOL WHICH CAN BE USED IN MANY FIELDS OF ENDEAVOR, INCLUDING THE GRAPHIC ARTS. IT IS THE PURPOSE OF THIS BOOK TO POINT OUT HOW TO MAKE EFFECTIVE SKETCHES AND TO SUGGEST VARIOUS MATERIALS AND TECHNIQUES WITH WHICH TO ACCOMPLISH THIS.

SKETCHING IS JUST ANOTHER FORM OF DRAWING, EXCEPT THAT IT IS LOOSE, SPONTANEOUS, AND NOT TOO PRECISE. THERE ARE, OF COURSE, VARIOUS DEGREES OF EXECUTION, FROM A 30-SECOND SKETCH TO ONE THAT TAKES AN HOUR OR SO.

IT IS NOT THE INTENT OF THIS BOOK TO BE TOO TECHNICAL OR TO STRESS ONE TECHNIQUE OVER ANOTHER. UPON CONTINUED INVESTIGATION AND PRACTICE, ONE WILL DEVELOP ONE'S OWN SKETCHING TECHNIQUE MUCH AS IS DONE IN PENMANSHIP.

FINALLY, ALL OF THE HELP AND ADVICE PRESENTED HERE WILL BE OF LITTLE USE TO ANYONE WITHOUT INTENSIVE AND PERSISTENT PRACTICE.

ALL SKETCHES IN THIS BOOK ARE ACTUAL SIZE.

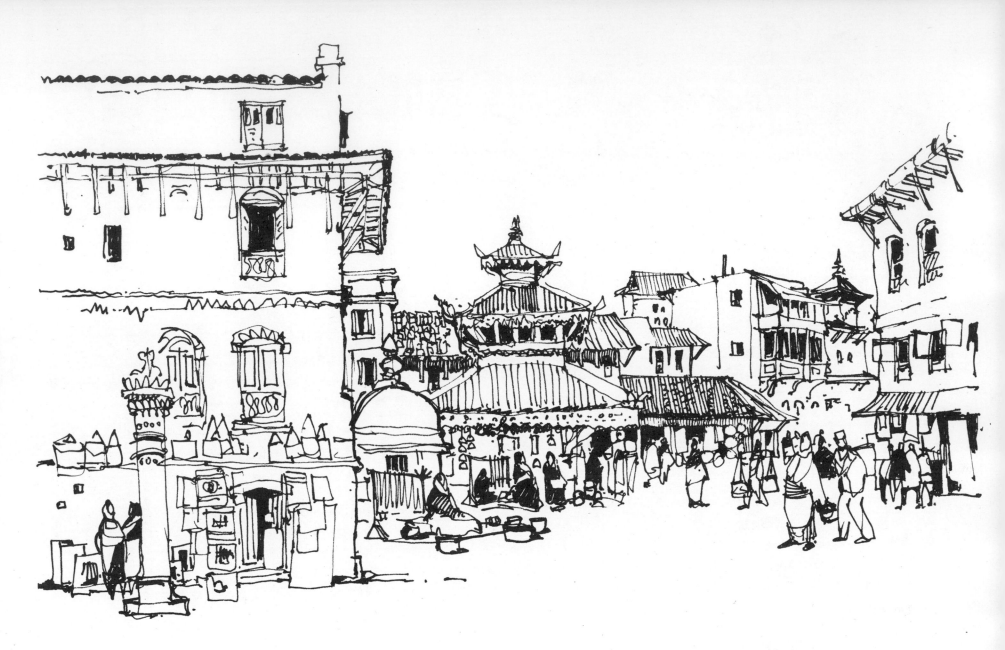

KATHMANDU
NEPAL '78

6

MATERIALS

THERE ARE MANY PENS OF THE METAL-POINT AND FIBER-TIP TYPE. THERE ARE MANY PENCILS OF THE GRAPHITE, CARBON, CHARCOAL, AND WAX-BASED TYPE. IN BOTH PENS AND PENCILS, THERE IS A VARIETY OF COLOR, DEGREE OF SOFTNESS, TEXTURE, AND THICKNESS OF LINE. IN ALL, THERE IS A TOOL FOR EVERYONE AND FOR EVERY TYPE OF SKETCHING RESULT, AND THERE ARE MANY SURFACES UPON WHICH TO SKETCH.

EXPERIMENT WITH ALL TYPES, AND USE THOSE WITH WHICH YOU HAVE THE MOST SUCCESS.

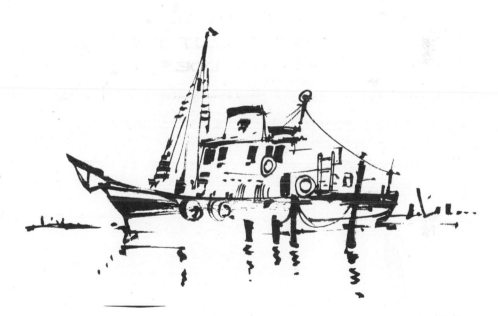

	EXAMPLE ON PAGE
## WOOD-CASED PENCIL	
GRAPHITE: INEXPENSIVE-AVAILABLE-CAN VARY SHAPE OF POINTS-CLEAN-BLENDS AND SHADES - A VARIETY OF GRADES OF SOFTNESS	90
CHARCOAL: CHALK-LIKE CONSISTENCY-VERY VOLATILE - JET BLACK-BLENDS AND SHADES-MUST BE FIXED.	92
CARBON: SAME AS ABOVE-CARBON MORE DENSE-LESS VOLATILE-MUST BE FIXED	80, 84
WAX-BASED: GOOD JET BLACKS-BLENDS AND SHADES WELL- DRY BRINGS OUT THE TEXTURE OF DRAWING SUR- FACE - DOES NOT SMEAR	21, 45, 81, 87
## SKETCH PENCIL	
ROUND LEAD	
SOFT - ROUND LEAD - LARGER THAN REGULAR LEAD - GOOD FOR LOOSE SKETCHES - VERSATILE - SMEARS	127, 130
RECTANGULAR LEAD	
SOFT - RECTANGULAR SHAPED LEAD - PROVIDES A VARIETY OF STROKE WIDTHS - UNIQUE RESULTS	85, 121

	EXAMPLE ON PAGE
<u>LITHOGRAPH PENCIL</u> VERY SOFT - WAX LIKE - JET BLACK - WEARS RAPIDLY - BRINGS OUT TEXTURE OF DRAWING SURFACE	89
<u>MECHANICAL PENCIL</u> REGULAR LEAD: WORKS WELL FOR SMALL SKETCHES FINE LEAD: VARIETY OF FINE LEAD SIZES - BREAKS EASILY - SKETCHES LIMITED IN SIZE OR BECOME, TEDIOUS IN EXECUTION	91
<u>MECHANICAL PENCIL</u> DRAFTING TYPE: OFFERS A VARIETY OF REPLACEABLE LEAD GRADES - HANDLES LIKE A PENCIL - CAN SHAPE LEAD POINTS - GOOD FOR SKETCHING	103
<u>LITHO CRAYON STICK</u> <u>CONTÉ CRAYON STICK</u> MAY BE USED AS CRAYON WITH HOLDER - USED ON EDGE PROVIDES UNIQUE RESULTS - BRINGS OUT TEXTURE OF DRAWING SURFACE	95 96, 119

9

	EXAMPLE ON PAGE
## WRITING PEN INEXPENSIVE - RIGID POINT - WATER-SOLUBLE INK - CARTRIDGE INK SUPPLY - GOOD FOR WRITING AND SKETCHING	56, 78, 102 120
## SKETCHING PEN FLEXIBLE POINT - PROVIDES DIFFERENT CHARACTER TO STROKE - WATERPROOF INK - GOOD FOR INK AND WASH SKETCHING - RESERVOIR INK SUPPLY - MUST BE CLEANED AND MAINTAINED CONSTANTLY	15, 46, 82 124, 126
## DRAFTING PEN VARIETY OF INTERCHANGEABLE POINT SIZES - MUST SKETCH WITH PEN HELD VERTICALLY FOR BEST RESULTS - USES WATERPROOF INK - RESERVOIR INK SUPPLY	34, 98, 100 114, 122, 123
## "GRAPHOS" PEN A VARIETY OF DIFFERENT POINT TYPES - THE FLOW OR BARREL TYPE AND BALL TYPE ARE SUITABLE FOR SKETCHING - RESERVOIR INK SUPPLY	129, 130

	EXAMPLE ON PAGE

FELT-TIP PEN

REPLACEABLE FELT TIPS OF DIFFERENT SIZES AND SHAPES - VERSATILE - USE TIPS DRY OR WET - RESERVOIR INK SUPPLY

106

FIBER-TIP PENS

6, 14, 30, 101, 113 115

FINE TIP : GOOD FOR LINE DRAWINGS AND SMALL SKETCHES

88, 99, 108, 124

MEDIUM TIP : SAME AS ABOVE - HEAVIER LINE - FAST SKETCHING

104

LARGE TIP : GOOD FOR BROAD STROKES AND FAST SKETCHING - NOT GOOD FOR DETAIL

7, 22, 46, 58, 67, 72, 79, 97, 112, 116, 117, 118, 128

SHAPED TIP : VERSATILE - THICK AND THIN LINES - FAST SKETCHING - VARIETY OF RESULTS WITH POINTS, HAND PRESSURE AND DRYNESS OF POINT

	EXAMPLE ON PAGE
BRUSH TIP : VERY THICK LINES - MUST KEEP SKETCH SIMPLE - RAPID FLOW OF INK	4
BALL-POINT PEN: SINGLE LINE QUALITY - USUALLY FINE - WATER-SOLUBLE INK SUPPLY - NOT GOOD FOR LARGE SKETCHES	86, 94, 109, 110
PEN POINTS QUILL POINT : FLEXIBLE POINT - VARIETY OF POINTS AVAILABLE - UNIQUE CHARACTER TO SKETCH - MUST DIP IN INK BOTTLE	93
BALL-POINT (SPEEDBALL) : SMOOTH EVEN LINE - HOLDS MORE INK THAN QUILL POINT - MUST BE DIPPED	105

12

SKETCHING PAPERS

SKETCHBOOKS AND SKETCHING PAPERS OFFER A VARIETY OF SURFACES, RANGING FROM THE HARD PLATE SURFACE OF BRISTOL BOARD TO PAPERS WITH SMOOTH, ROUGH, TEXTURED, AND ABSORBENT SURFACES. WITH EACH DRAWING TOOL AND WITH EACH SURFACE, ONE CAN ACHIEVE A DIFFERENT EFFECT. THE COMBINATIONS YIELD A WIDE VARIETY OF RESULTS. FOR PRACTICE SKETCHING, INEXPENSIVE TYPING PAPER IS MOST SATISFACTORY, AND A STACK SHOULD BE KEPT ON HAND. WHEN DOING MORE THAN PRACTICE SKETCHES, THE USE OF BETTER QUALITY PAPER IS RECOMMENDED FOR DURABILITY, LONGEVITY, AND NON-YELLOWING CHARACTERISTICS.

IN ADDITION, THERE ARE MANY COLORED PAPERS OF DIFFERENT SURFACE QUALITIES THAT PROVIDE INTERESTING RESULTS WITH BLACK AS WELL AS COLORED SKETCHING TOOLS.

SKETCH BACKING

THE BACKING BEHIND THE SKETCHING SURFACE IS QUITE IMPORTANT IN USING CARBON, GRAPHITE, OR WAX-BASED PENCILS. FOR INSTANCE, A VERY HARD SURFACE DIRECTLY UNDER THE SKETCHING PAPER WOULD BE UNYIELDING, WHEREAS A PILE OF ADDITIONAL PAPER UNDER THE SKETCHING PAPER WOULD ALLOW FOR INDENTING THE SURFACE AT THE EDGE OF THE DRAWING MEDIUM. THIS RESULTS IN VERY SHARP AND CRISP EDGES TO THE STROKE. AGAIN, ONE MUST EXPERIMENT TO FIND THE SURFACE THAT PROVIDES THE DESIRED RESULTS.

13

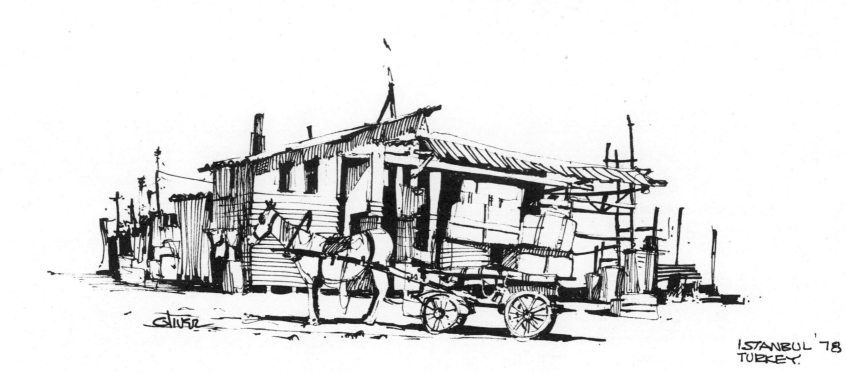

ISTANBUL '78
TURKEY.

14

THE SKETCH

A SKETCH IS THE PRODUCT OF A VARIETY OF LINES ASSEMBLED TO MAKE SHAPES THAT RESEMBLE REALISTIC FORMS. DETAIL IS ADDED TO THESE SHAPES TO GIVE THEM MORE MEANING AND IDENTITY. A FINAL DIMENSION IS ACHIEVED BY THE ADDITION OF TONES AND BLACK TO REPRESENT DIFFERENCES IN LIGHT ON THE VARIOUS PLANES AND TO DEPICT SHADOWS AND SHADES.

ONE MUST DEVELOP A QUICK, CONFIDENT, POSITIVE, AND ACCURATE STROKE OF LINE IN ORDER TO MAKE CONVINCING SHAPES, DETAILS, AND TONES. THIS TAKES MANY HOURS OF SIMPLE PRACTICE.

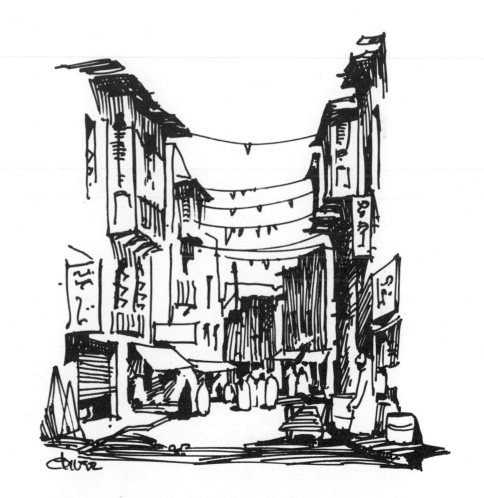

THE EVOLUTION OF A SKETCH

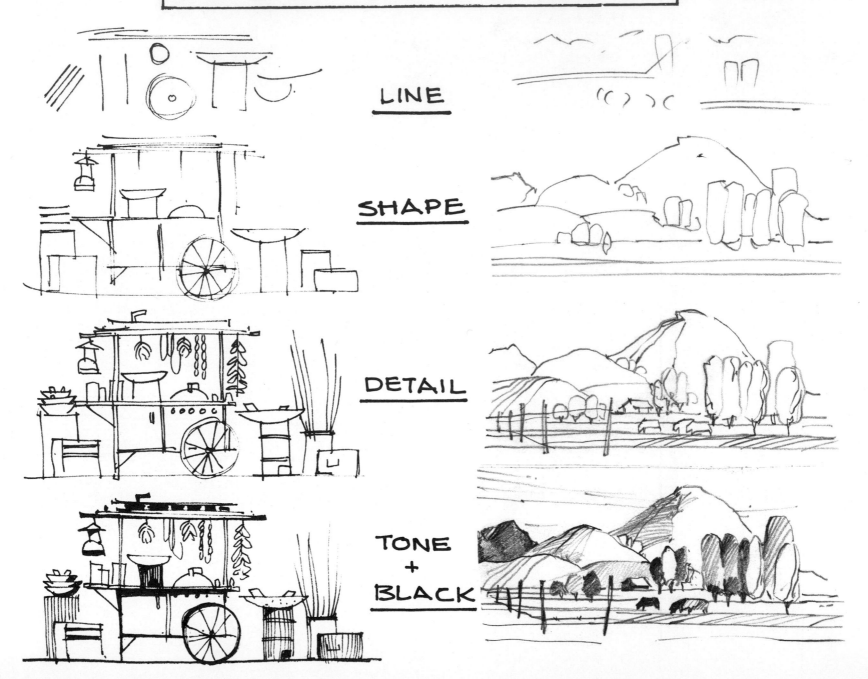

LINE

SHAPE

DETAIL

TONE
+
BLACK

16

THE LENGTH AND CONTROL OF THE LINE STROKE ARE THE PRODUCTS OF THE FREEDOM OF MOVEMENT IN FINGERS, WRIST, ELBOW, AND SHOULDER.

MOST STROKES, EVEN SHORT STROKES, CAN AND SHOULD BE MADE WITH A GLIDING MOTION, USING THE SHOULDER AS A PIVOT POINT. THIS MAKES POSITIVE AND TRUE LINES.

USE THE SIDE OF THE LITTLE FINGER AS A STEADYING POINT UPON WHICH TO GLIDE THE HAND.

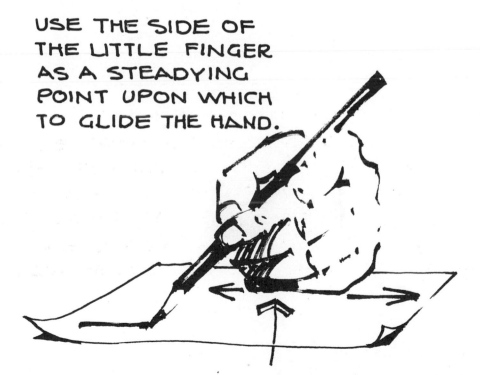

LINE

FINGER MOVEMENT ONLY
LENGTH OF STROKE IS LIMITED.

WRIST MOVEMENT ONLY
NOTE THE FORCED CURVATURE OF LINE.

SHOULDER AND ELBOW MOVEMENT ONLY

FREEDOM OF MOVEMENT OF ALL PIVOT POINTS RENDERS A WIDE VARIETY OF STROKES.

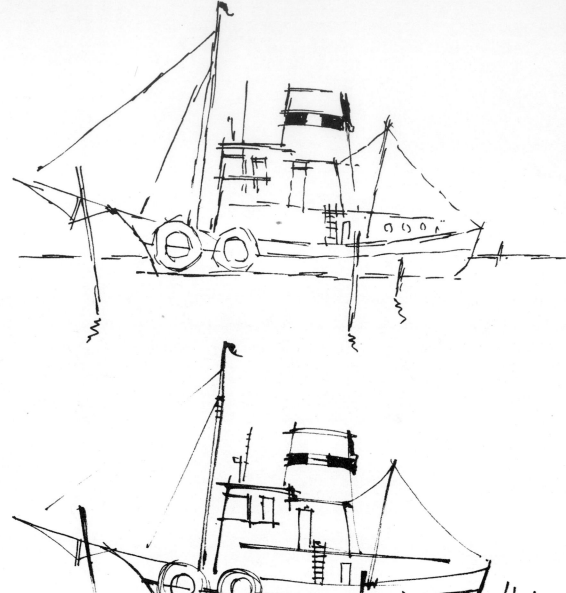

TYPES OF STROKES

THE STROKES IN THE SKETCH TO THE LEFT WERE DONE WITH FINGER MOVEMENTS. IT IS AN ACCEPTABLE SKETCH, BUT IT LACKS CONFIDENCE OF STROKE AND SPONTANEITY OF EXPRESSION.

THIS SKETCH WAS MADE WITH MOVEMENTS MAINLY FROM THE SHOULDER. THE DETAIL WAS PLACED IN WITH FINGER MOVEMENTS. IT WAS DONE FASTER AND IS A STRONGER SKETCH THAN ABOVE.

18

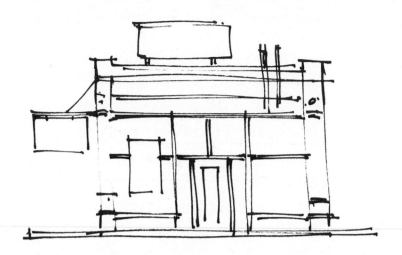

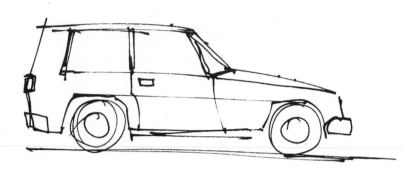

THE SKETCHES ABOVE ARE DRAWN WITH A DISCIPLINED STROKE.
THE SKETCHES BELOW ARE DRAWN WITH A LOOSE, FREE-FLOW-
ING STROKE. BOTH ARE ACCEPTABLE BUT RESULT IN SKETCHES
OF DIFFERENT CHARACTER.

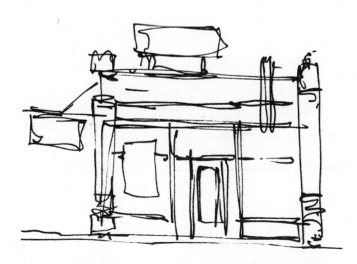

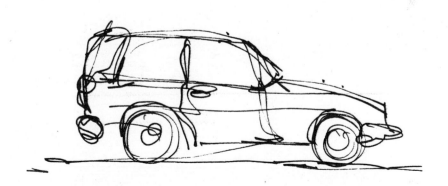

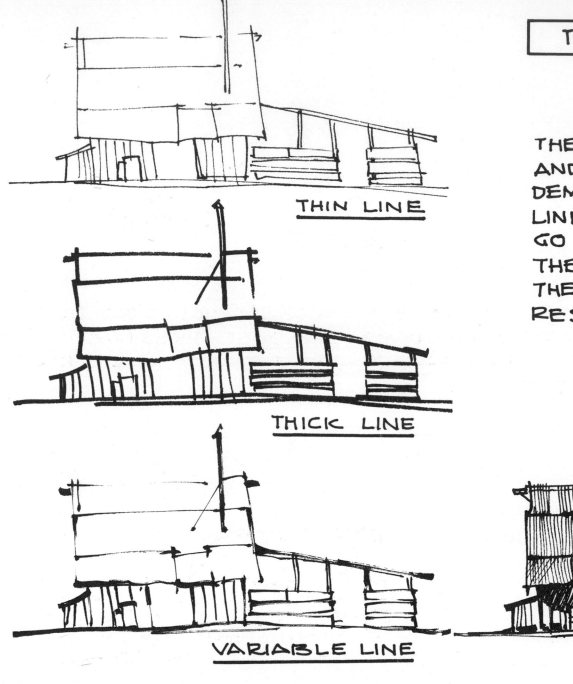

THIN LINE

THICK LINE

VARIABLE LINE

THE ILLUSTRATIONS ON THIS AND THE OPPOSITE PAGE DEMONSTRATE THE VARIOUS LINE QUALITIES THAT CAN GO INTO MAKING A SKETCH. THE MORE VARIETY OF LINE, THE MORE INTERESTING THE RESULT.

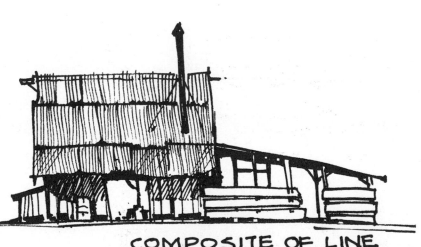

COMPOSITE OF LINE

TYPE OF LINE • PENCIL •

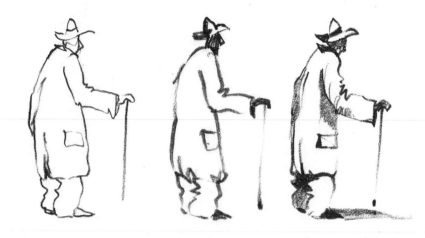

THIN
LINE

VARIABLE
LINE

COMPOSITE
OF LINE

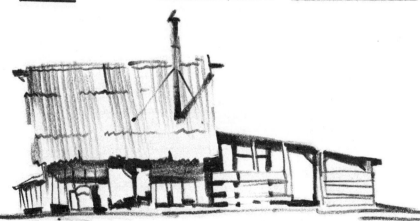

COMPOSITE OF LINE

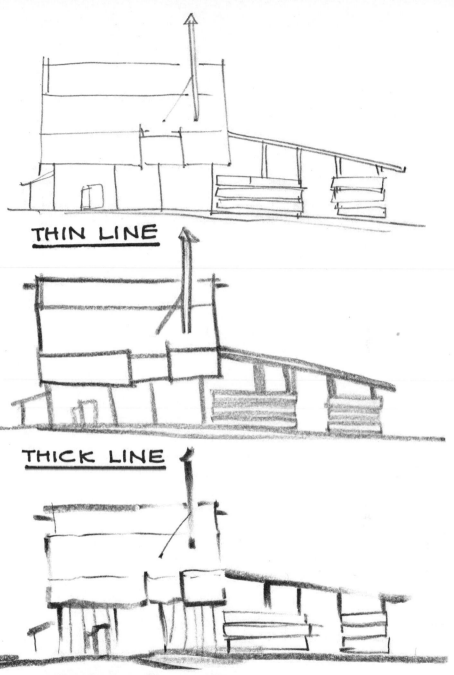

THIN LINE

THICK LINE

VARIABLE LINE

21

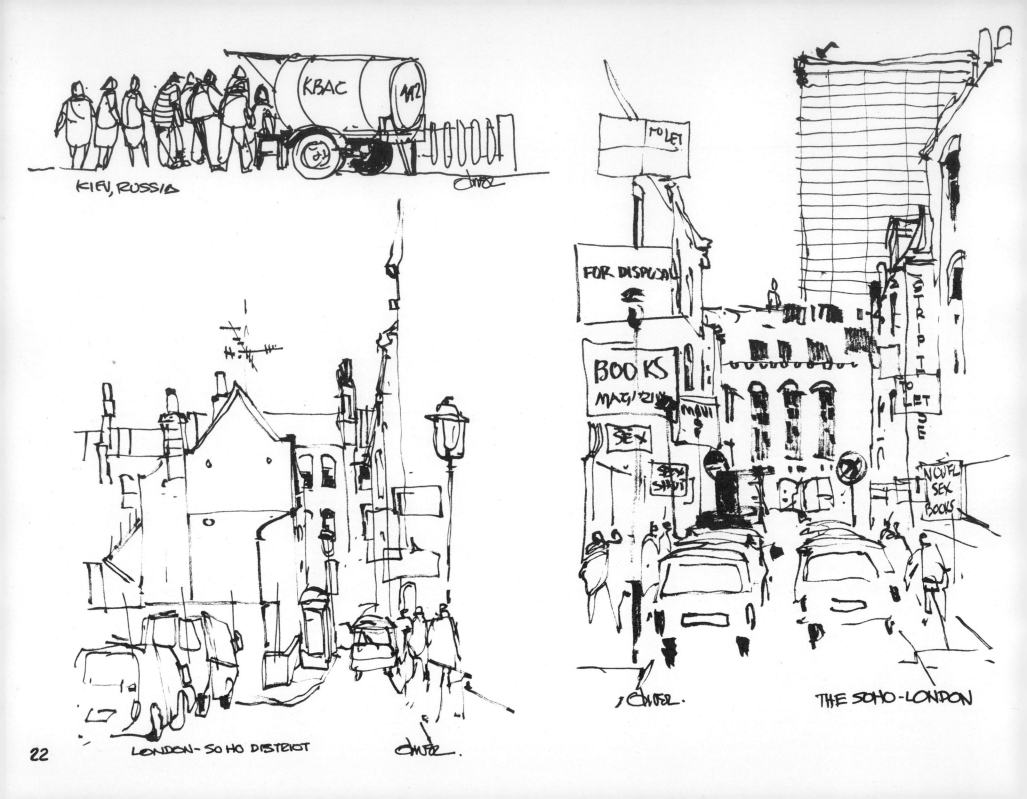

KIEV, RUSSIA

KBAC 112

FOR DISPOSAL

TO LET

BOOKS
MAGAZINE

SEX

SEX SHOP

STRIP TEASE
TO LET

NOVEL
SEX
BOOKS

LONDON-SOHO DISTRICT

THE SOHO-LONDON

22

SHAPE ④

GEOMETRIC SHAPES CONSTITUTE THE FRAMEWORK OF THE MANY OBJECTS IN A SKETCH. LINES DEFINE THE SHAPES UPON WHICH DETAIL IS APPLIED TO GIVE REALITY.

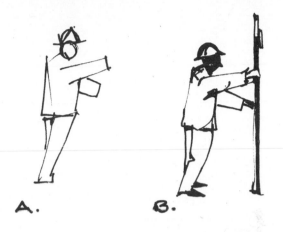

A. B.

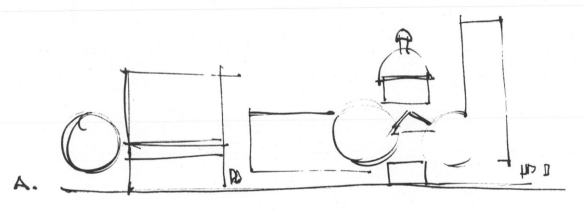

A.

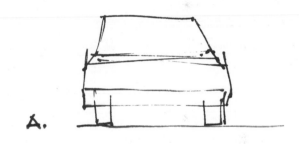

A.

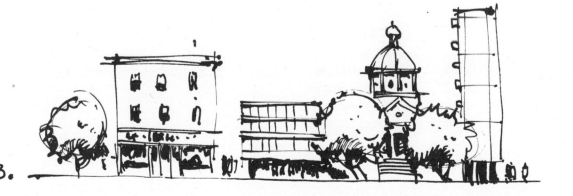

B.

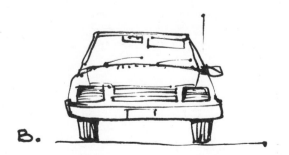

B.

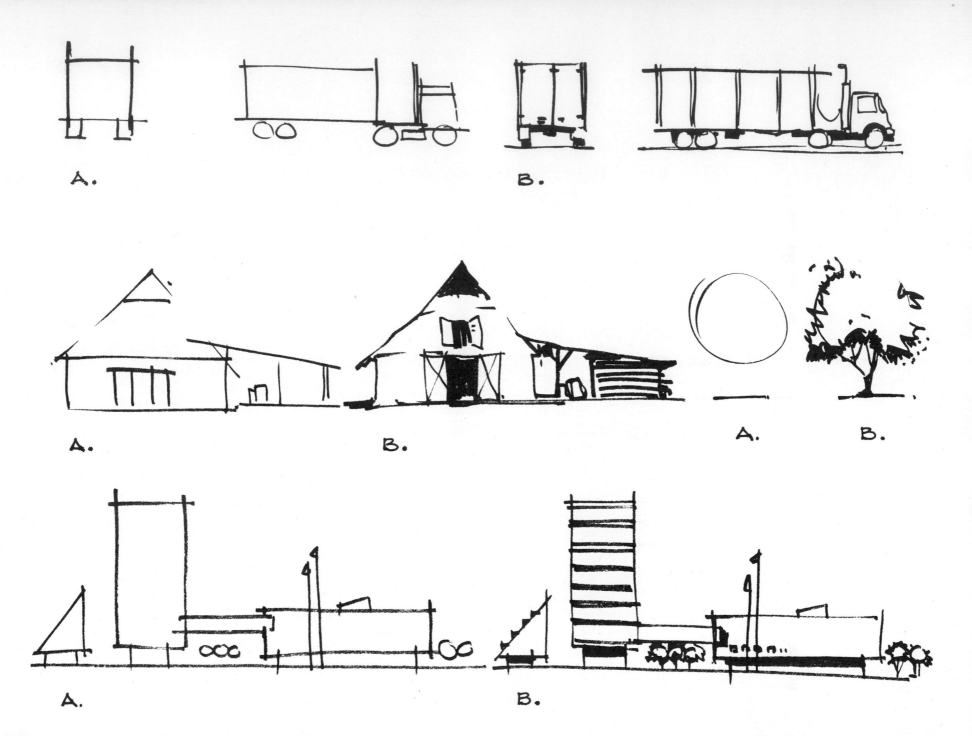

A.

B.

A.

B.

A.

B.

A.

B.

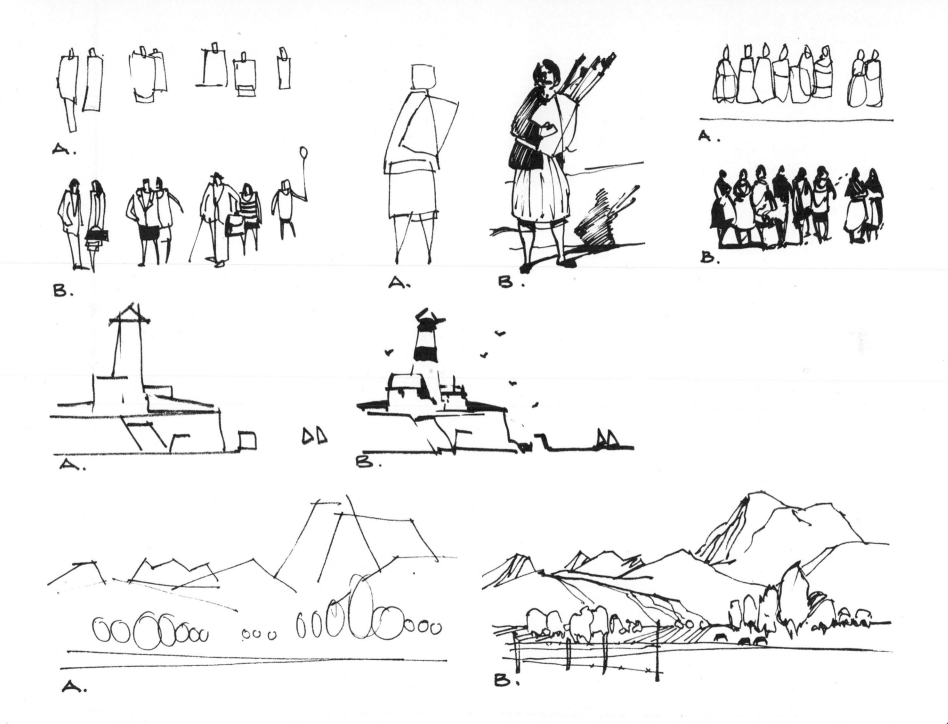

A.

B.

A.

B.

A.

B.

A.

B.

A.

B.

25

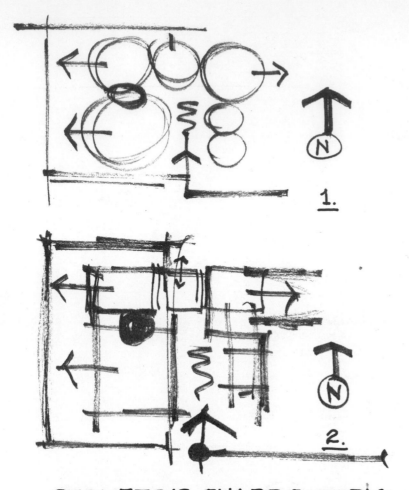

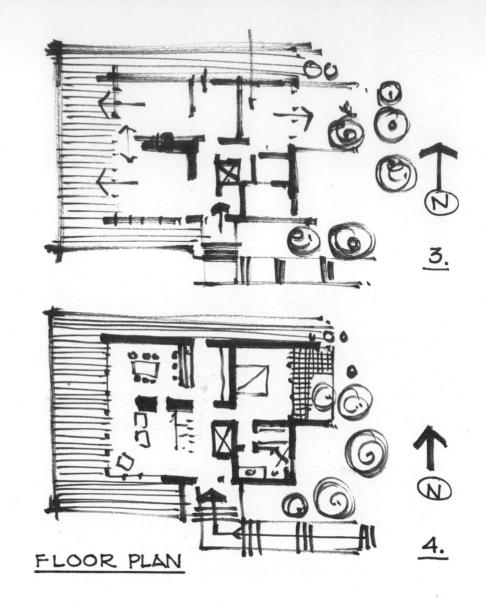

1.

2.

3.

FLOOR PLAN

4.

GEOMETRIC SHAPES FORM
THE BASIS FOR BUILDING
UP MANY SKETCHES
RAPIDLY.

THE SKETCHES ON THIS AND THE OPPOSITE PAGE SHOW THE
DEVELOPMENT OF ARCHITECTURAL FORMS THROUGH THE
FREE BUT POSITIVE SKETCHING OF GEOMETRIC SHAPES IN
LINE FORM.

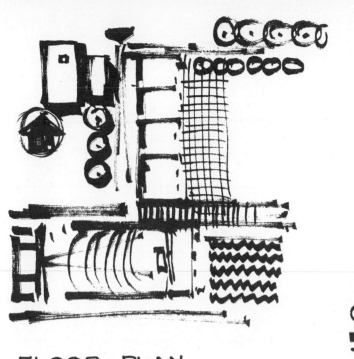

FLOOR PLAN

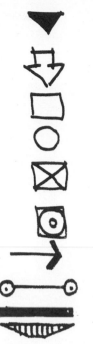

SYMBOLS

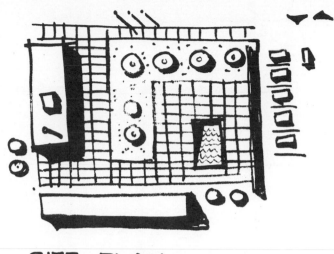

SITE PLAN

THERE ARE MANY OTHER
USES FOR SIMPLE GEOMETRIC
SHAPES IN DIAGRAMING AND
COMMUNICATING THROUGH
SYMBOLS AND FORMS.

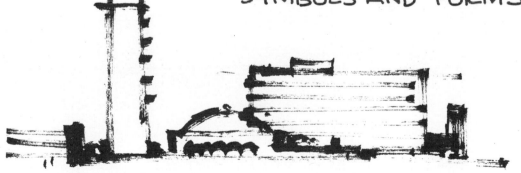

ELEVATION

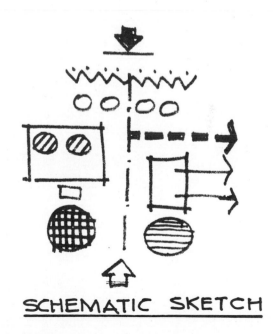

SCHEMATIC SKETCH

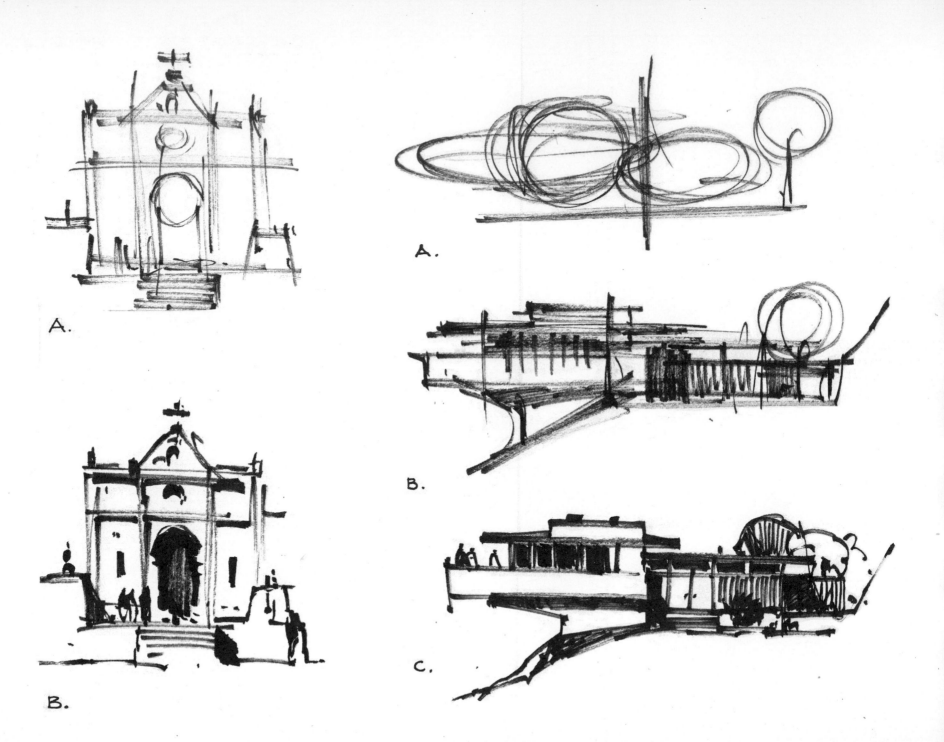

A.

B.

A.

B.

C.

28

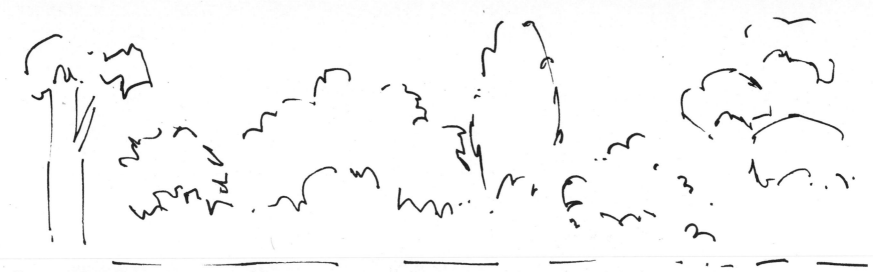

IN ORDER TO SKETCH LANDSCAPE FORMS, ONE MUST FIRST
DESCRIBE THE GENERAL SHAPE OF THE FOLIAGE MASS AS
SHOWN IN THE VARIOUS FORMS ABOVE.

THE DETAIL OF LEAF CONFIGURATION AND TRUNK STRUCTURE
IS THEN SKETCHED IN TO FURTHER DEFINE THE TREE OR BUSH.

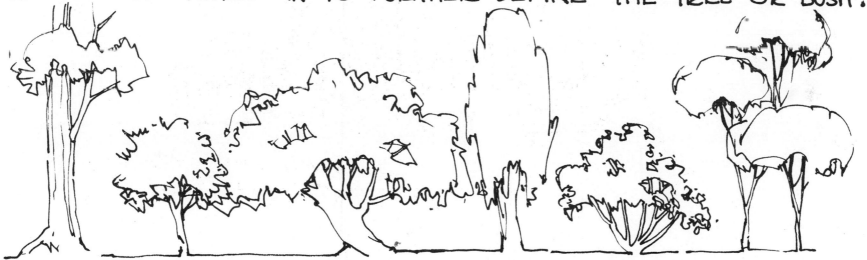

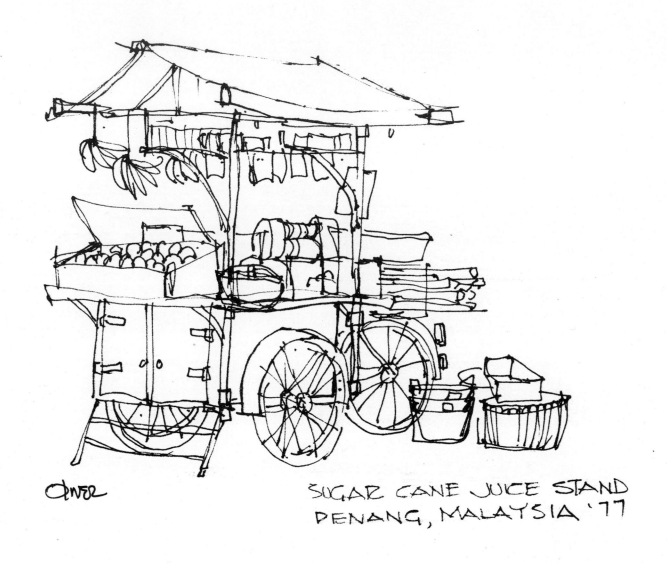

Oliver

SUGAR CANE JUICE STAND
PENANG, MALAYSIA '77

DETAIL

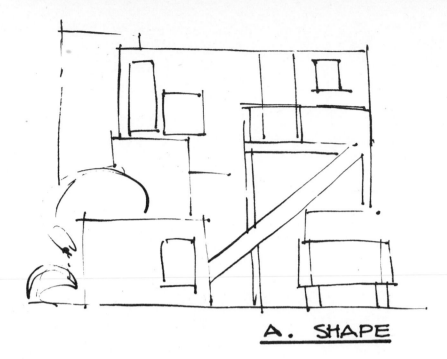

A. SHAPE

THE SHAPE OF THE OBJECT OR PARTS OF A SCENE ARE DEFINED AS IN FIGURE A. DETAIL WITHOUT THE SHAPE IS SHOWN IN FIGURE B. FIGURE C SHOWS THE ADDITION OF THE DETAIL ON THE SHAPE, RESULTING IN A COMPLETED LINE SKETCH.

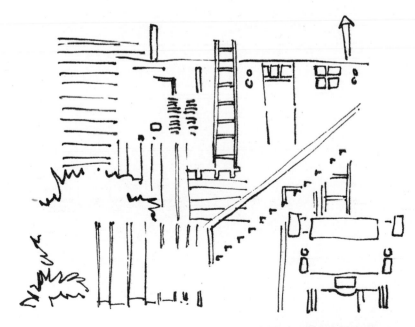

B. DETAIL

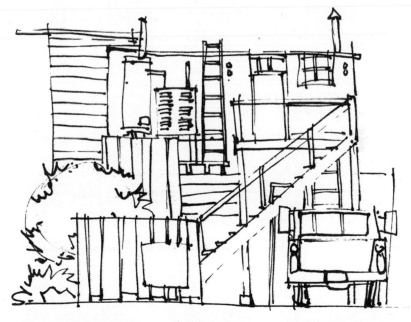

C. SHAPE + DETAIL = SKETCH

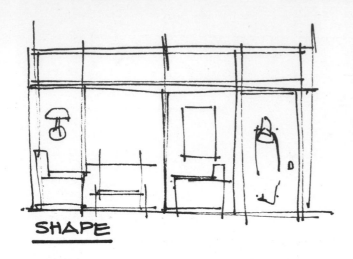

SHAPE

THE SKETCHES ON
THIS AND THE NEXT
PAGE SHOW THE CON-
STRUCTION OF SHAPES
AND THE DETAIL ADDED
TO DEFINE AND GIVE
REALITY TO THE SKETCH.

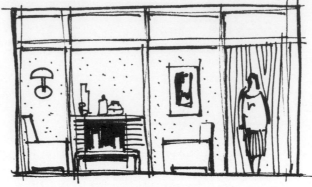

SHAPE + DETAIL

SHAPE SHAPE +
DETAIL

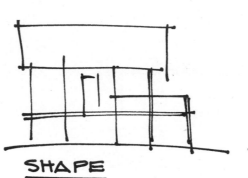

SHAPE

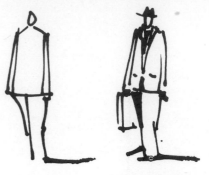

SHAPE + DETAIL

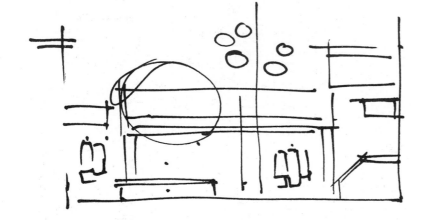

SHAPE

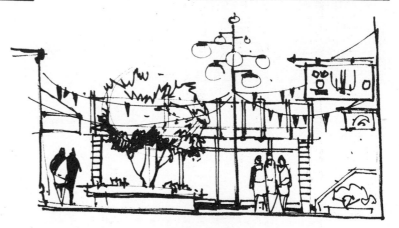

SHAPE + DETAIL

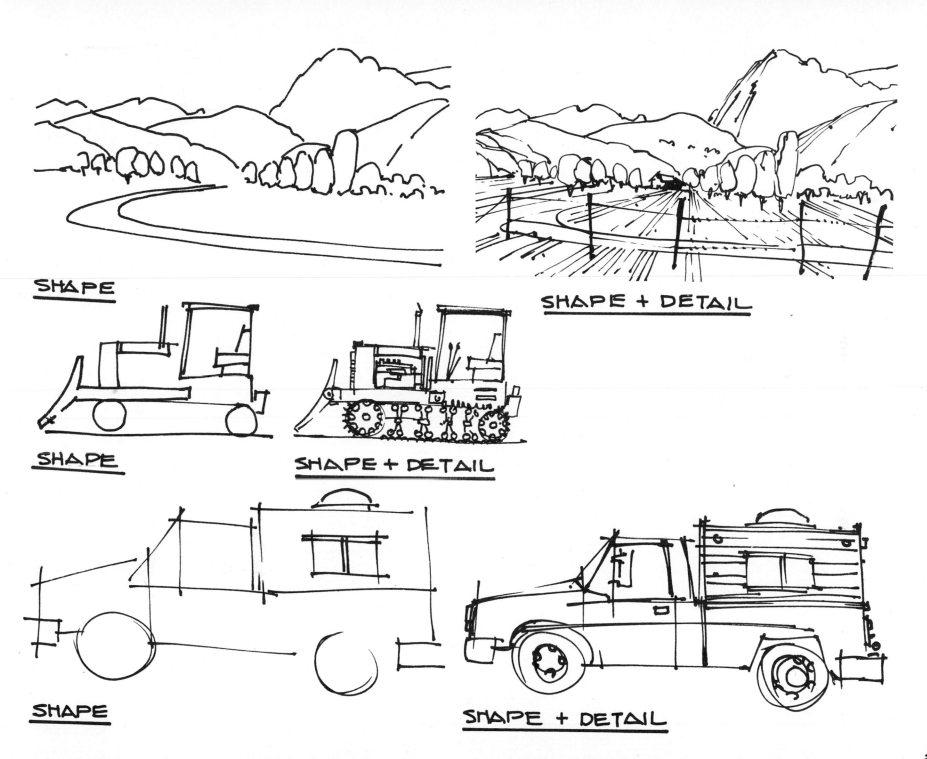

SHAPE

SHAPE + DETAIL

SHAPE

SHAPE + DETAIL

SHAPE

SHAPE + DETAIL

33

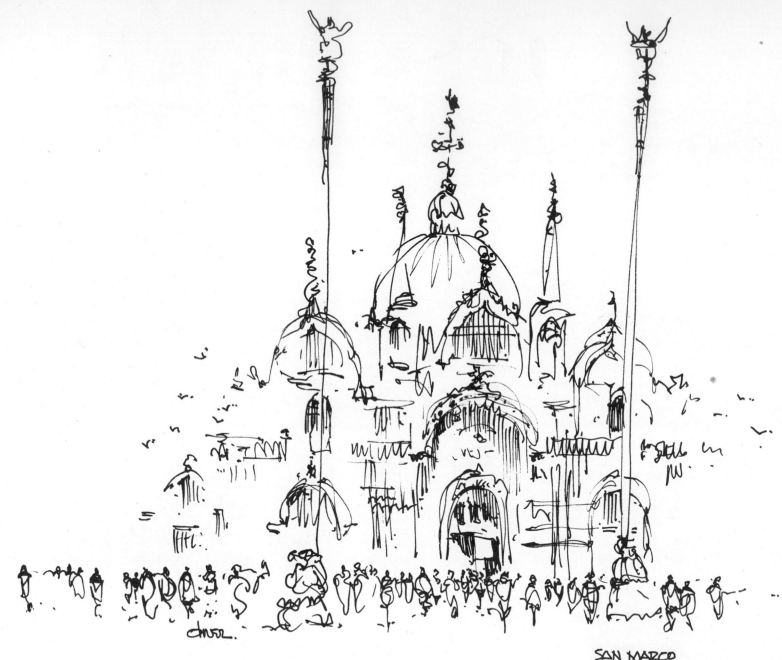

SAN MARCO
VENICE ITALY

TONE + BLACK

THE TONE AREAS ON SURFACES IN A SKETCH TEND TO INCREASE THE APPARENT DEPTH, DIMENSION, AND INTEREST.

A.

FIGURES A AND B

THE TONE AREAS CAN BE UNIFORM OR VARIABLE.

FIGURE C

THE ADDITION OF DARKS OR BLACK TO A SKETCH PROVIDES AN EXCLAMATION POINT. IT CAN MAKE A DULL SKETCH EXCITING.

B.

C.

35

LINES DEFINE
THE SHAPE

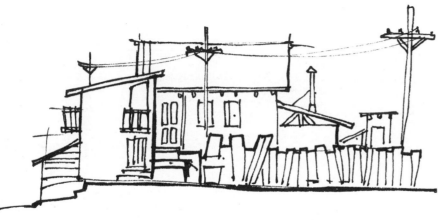

DETAIL IS ADD-
ED TO THE
SHAPE

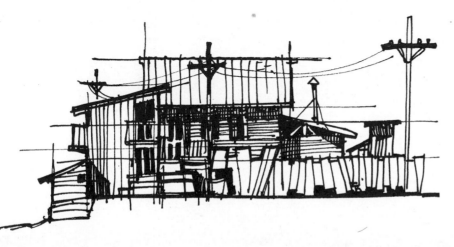
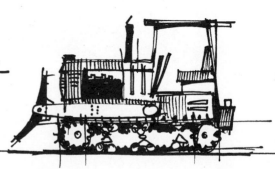

TONE + BLACK
IS ADDED TO
THE DETAILED
SHAPE

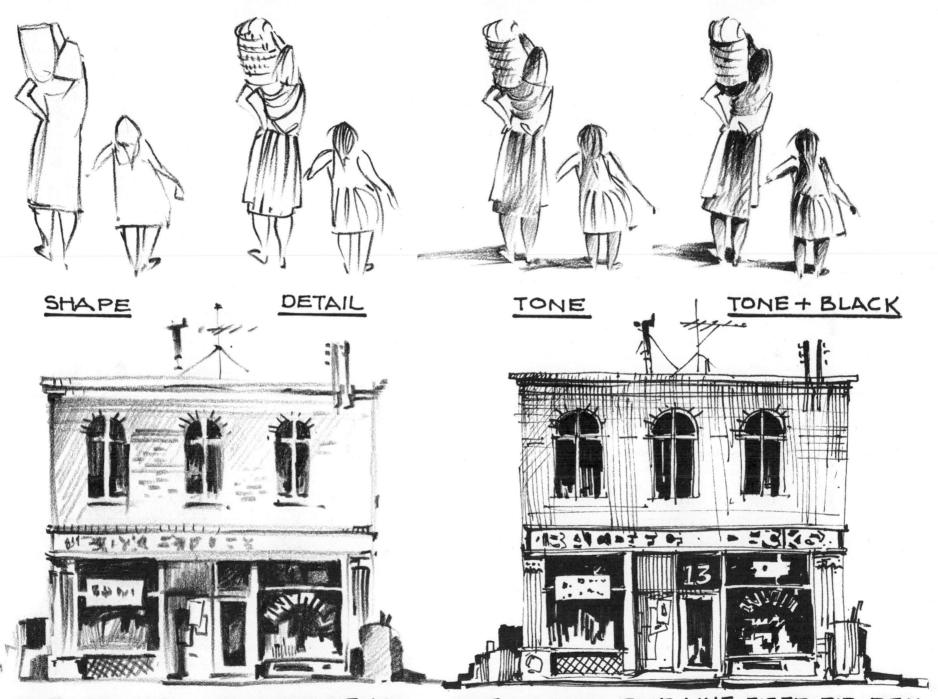

SHAPE DETAIL TONE TONE + BLACK

TONE + BLACK WAX-BASE PENCIL

TONE + BLACK FINE LINE FIBER-TIP PEN

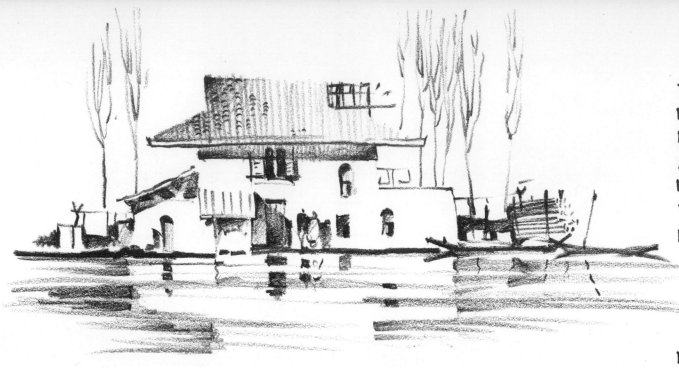

THIS SKETCH WAS DONE WITH A WAX-BASE PENCIL, WHICH ALLOWED FOR A FULL RANGE OF VARIABLE TONES PLUS BLACK.

NOTE THE IMPACT OF THE BLACK AREAS IN EACH SKETCH.

THIS SKETCH WAS DONE WITH AN INDIA INK SKETCH PEN. THE VARIABLE TONES ARE ACHIEVED THROUGH THE DENSITY OF LINE STROKES WITHIN AN AREA.

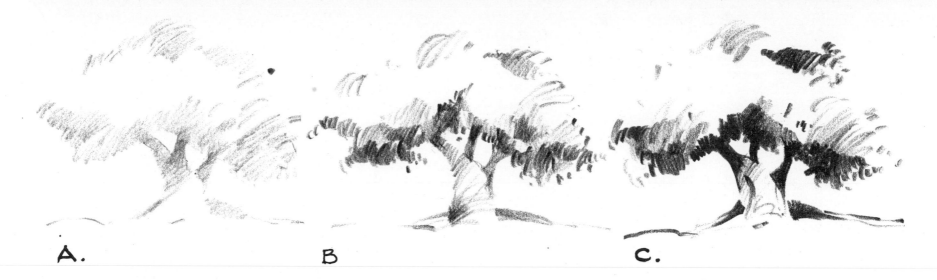

A. B C.

THE SKETCHES ON THIS PAGE ILLUSTRATE THREE STEPS IN THE USE OF TONE AND TONE PLUS BLACK.

FIGURE A UNIFORM TONE

FIGURE B VARIABLE TONE

FIGURE C TONE PLUS BLACK

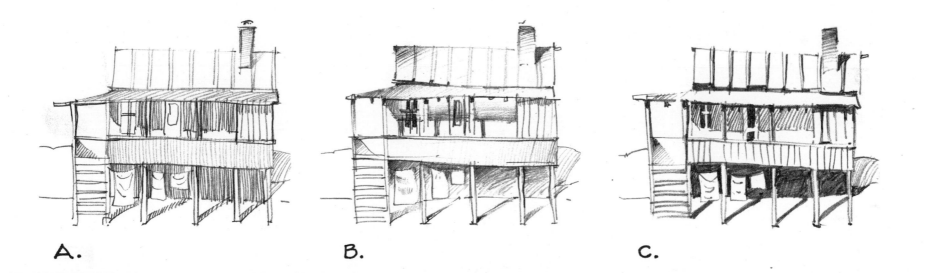

A. B. C.

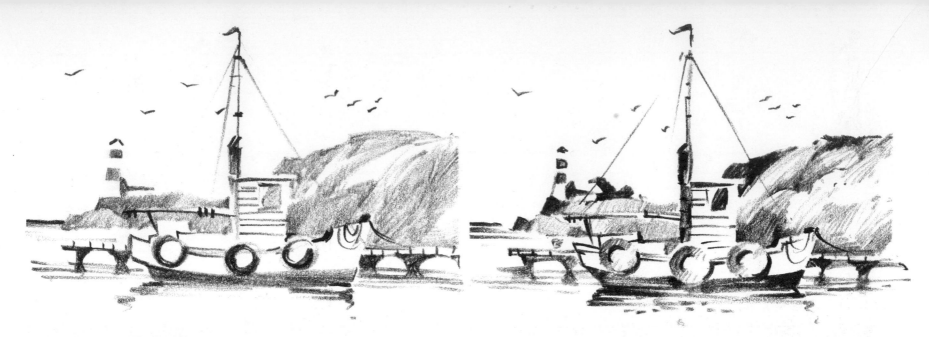

THESE EXAMPLES SERVE TO ILLUSTRATE HOW SKETCHES WITH UNIFORM TONES PLUS BLACK ARE ADEQUATE. BY MAKING THE TONES VARIABLE AND INTRODUCING MORE BLACK, THE SKETCHES ARE FURTHER ENHANCED.

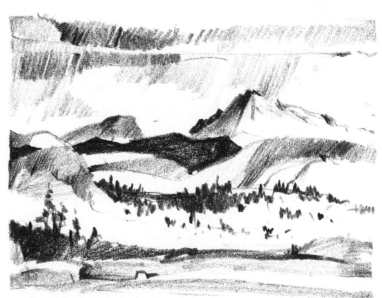

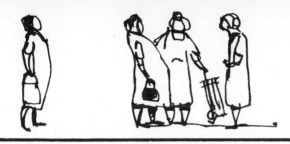

SHADOWS

THE USE OF SHADOWS IN A SKETCH PROVIDES AN ADDITIONAL WAY TO ACHIEVE A SENSE OF DIMENSION AND REALITY. IT CAN ALSO BE A MEANS FOR FOCUSING ATTENTION ON AREAS IN THE SKETCH AND FOR CREATING MOOD.

IN SKETCHING, IT IS NECESSARY TO BE AWARE OF THE EXISTENCE OF SHADOWS IN ACTUAL SCENES, WHAT CREATES THEM AND HOW THEY CHANGE WITH THE SUN'S LOCATION RELATIVE TO THE SCENE OR OBJECTS IN THE SCENE.

ONE MUST OBSERVE HOW SHADOWS PERFORM AND KNOW HOW TO MANIPULATE THEM

TO THE ADVANTAGE OF THE SKETCH. THIS TAKES A SMALL DEGREE OF EXPERIENCE. THERE ARE GEOMETRIC PROCEDURES THAT CAN BE USED TO ACCURATELY CONSTRUCT SHADOWS ON OBJECTS. HOWEVER, THE EMPHASIS IN THIS TEXT WILL BE ON ILLUSTRATING THE USE AND VALUE OF A SHADOW.

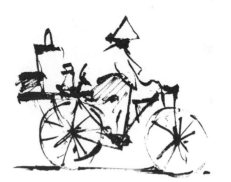

1. SHADOWS ARE THE DARK AREAS ON SURFACES, CAUSED BY AN OBJECT INTERRUPTING THE SUN'S RAYS.

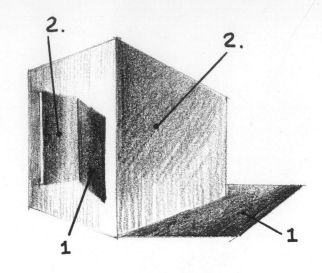

2. AREAS AWAY FROM THE SUN ARE SAID TO BE IN THE SHADE.

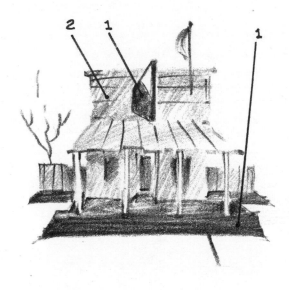

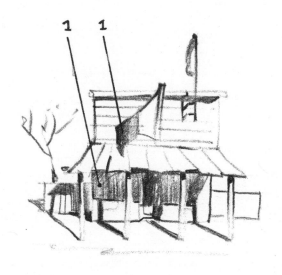

SUN FROM BEHIND THE OBJECT

SUN FROM THE RIGHT AND IN FRONT OF THE OBJECT — LOW OVERHEAD

SUN FROM THE LEFT AND IN FRONT OF THE OBJECT — HIGH OVERHEAD

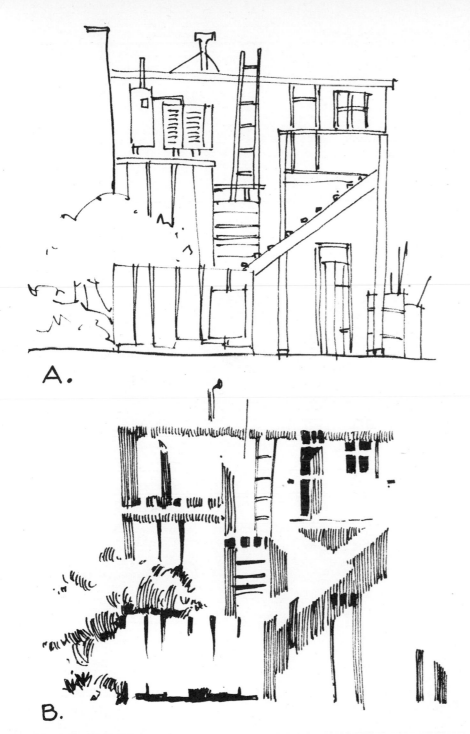

A.

FIGURE A SHOWS ONLY THE
SHAPE AND DETAIL IN THE
SKETCH.

FIGURE B SHOWS ONLY THOSE
AREAS THAT REPRESENT
SHADE OR SHADOW WITHOUT
SHAPE OR DETAIL.

FIGURE C SHOWS THE TOTAL
SKETCH, WHICH INCLUDES
SHAPE, DETAIL, AND TONE +
BLACK. THE TONAL AREAS
ARE THE SHADES AND
SHADOWS.

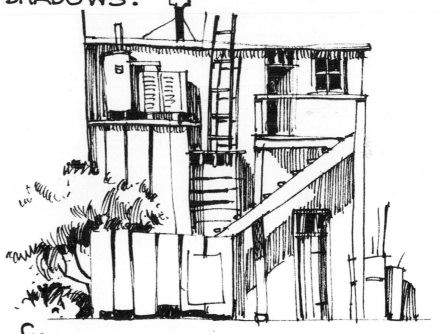

B.

C.

43

A. THIS SKETCH SHOWS ONLY
 THE SHADE AND SHADOW
 AREAS IN A SCENE.

B. THE SAME SCENE WITH
 DETAIL ADDED. THIS GIVES
 REALITY TO THE SKETCH.

C. THIS IS THE SAME SCENE
 WITH THE DIRECTION OF
 THE SUN REVERSED.

D. NOTE THE EFFECT CAUSED
 BY THE LIGHT OF THE SUN
 ON THE FIGURES.

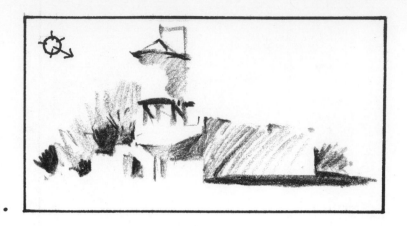

A.

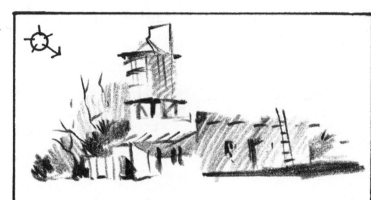

B.

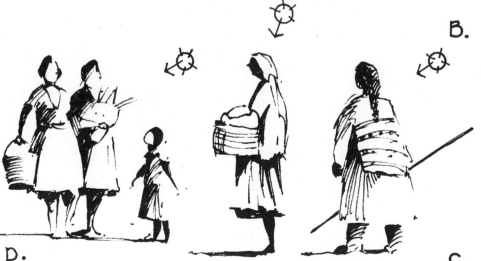

D.

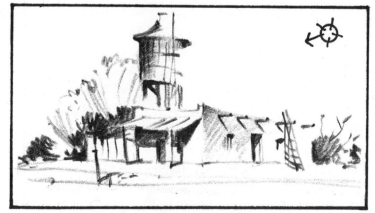

C.

REFLECTED LIGHT
UNDER OVERHANG

HIGHLIGHT ON
CHIMNEY TOP

REFLECTED
LIGHT

HIGH CONTRAST WITH WALL
CREATES DEPTH.

DARK FOREGROUND

VARIETY OF TONE
PROVIDES INTEREST.

NOTE THE VALUE CHANGE
THAT EXISTS IN ALL DARK
AREAS.

CHANGE IN VALUES
CREATES A 3-D EFFECT.

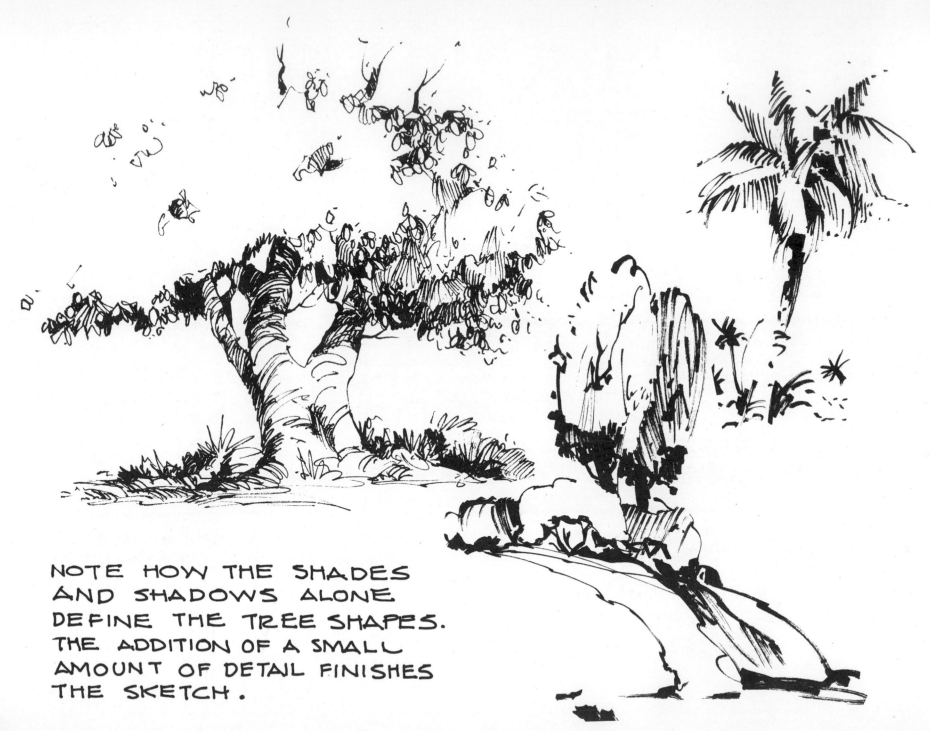

NOTE HOW THE SHADES
AND SHADOWS ALONE
DEFINE THE TREE SHAPES.
THE ADDITION OF A SMALL
AMOUNT OF DETAIL FINISHES
THE SKETCH.

COMPOSITION

THE PRECEDING PAGES HAVE DEALT WITH THE MECHANICS OF CONSTRUCTING A QUICK SKETCH USING LINE, SHAPE, DETAIL, AND TONE PLUS BLACK.

HOWEVER, IT IS NOT SUFFICIENT TO JUST RENDER A FACSIMILE OF A SCENE OR OBJECT. IT IS NECESSARY TO COMPOSE ALL ELEMENTS OF LINE, SHAPE, DE-TAIL, AND TONE PLUS BLACK IN-TO AN ORGANIZED AND EFFEC-TIVE STATEMENT. THIS IS KNOWN AS THE COMPOSITION OF THE SKETCH.

COMPOSITION CAN APPLY TO AN OBJECT OR GROUP OF OBJECTS AS WELL AS AN ENTIRE PICTURE FORMAT.

FOLLOWING ARE A FEW ILLUS-TRATIONS THAT COVER SOME BASIC CONCEPTS OF COMPOSI-TION. ONE'S SKETCHES CAN BE TESTED AGAINST THEM.

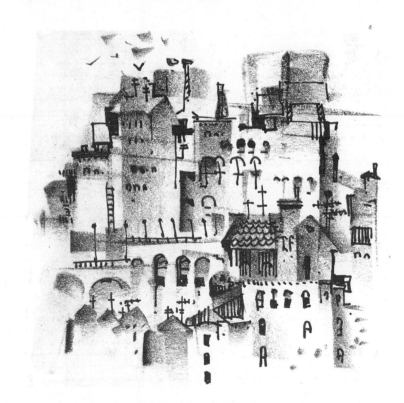

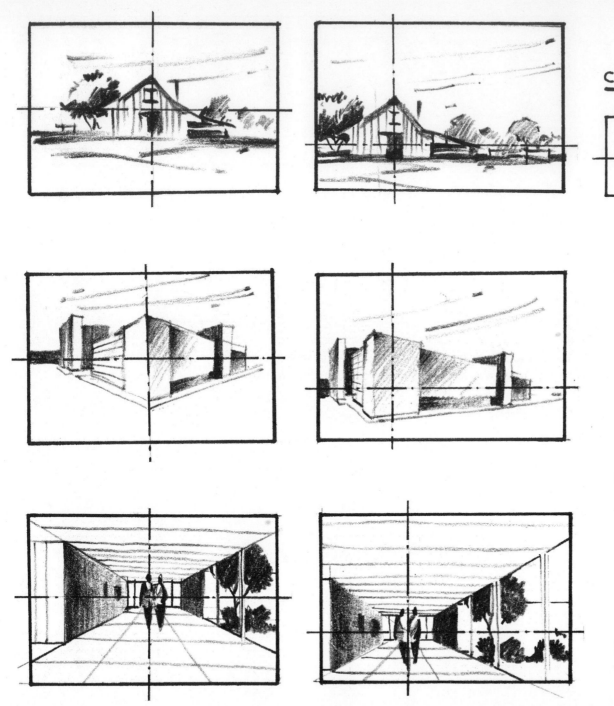

CENTER OF INTEREST

STATIC DYNAMIC

TO PROVIDE A MORE
INTERESTING FORMAT
FOR A PICTURE,
RAISE OR LOWER
THE LINE OF CENTER
OF INTEREST AND DO
THE SAME LATERALLY.

THIS PROVIDES A
MORE INTERESTING
DIVISION OF SPACE
WITHIN THE FORMAT.

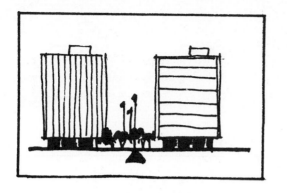

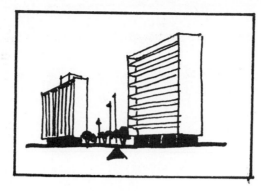

STATIC - SYMMETRICAL

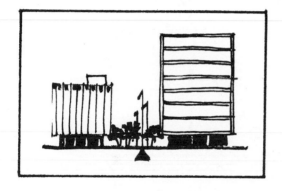

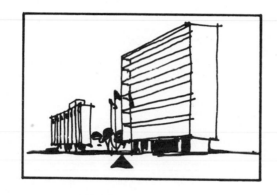

DYNAMIC - SYMMETRICAL

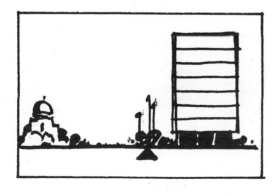

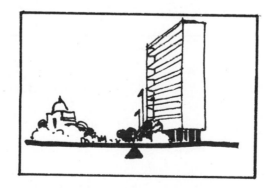

DYNAMIC - ASYMMETRICAL

FULCRUM
CENTER OF INTEREST

THE COMPOSITION OF A
PICTURE SHOULD BE IN
EQUILIBRIUM OR BAL-
ANCE, WITH THE CENTER
OF INTEREST FALLING
AT THE BALANCE POINT
OR FULCRUM. THERE ARE
EXCEPTIONS TO THIS,
HOWEVER, WHEN WANTS
TO ACHIEVE MORE DRA-
MATIC EFFECTS.

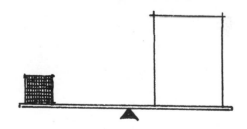

FULCRUM
CENTER OF INTEREST

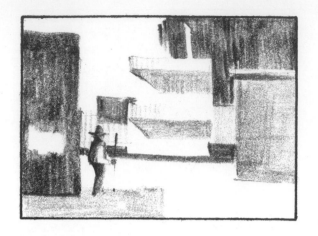

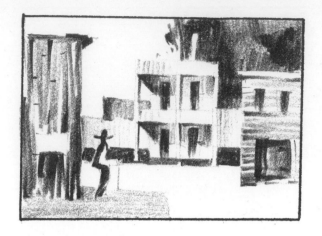

TWO-DIMENSIONAL PATTERNS ARE OVERLAID TO
CREATE AN ILLUSION OF DEPTH KNOWN AS FLAT
SPACE.

BY ADDING PERSPECTIVE TO THE INTERPLAY OF
PLANES AND VALUES, A MORE ACCURATE ILLUSION OF
DEPTH IS CREATED, WHICH IS KNOWN AS DEEP SPACE.

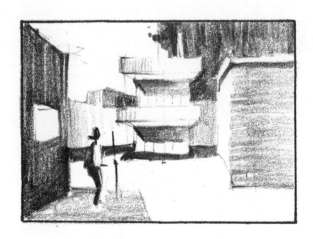

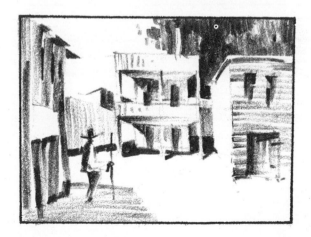

DEEP SPACE

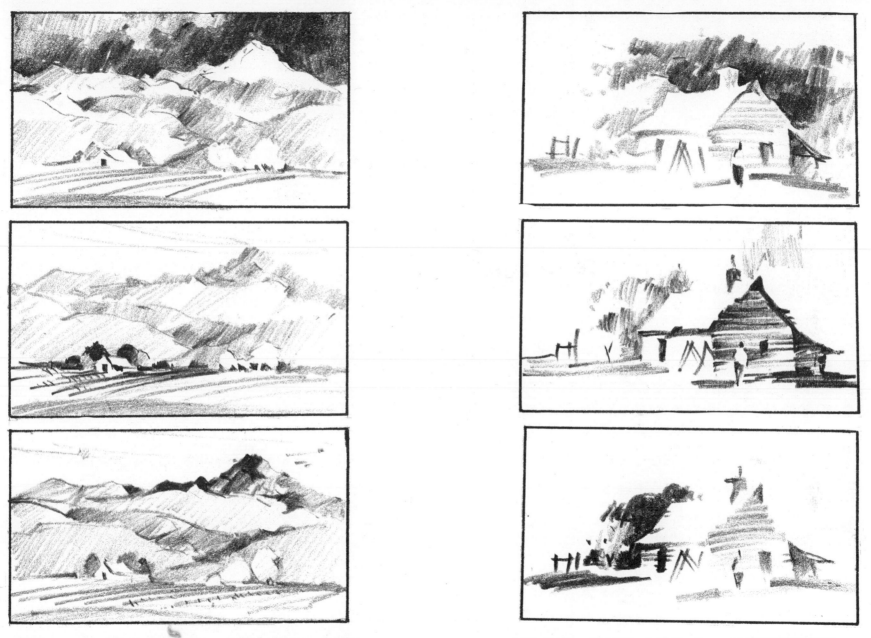

THE SKETCHES ABOVE SHOW HOW SHIFTING THE HIGH-CONTRAST
AREAS CAN SHIFT THE AREA OF INTEREST.

FOREGROUND

BACKGROUND

THE THREE MAJOR ELEMENTS MAKING UP A COMPOSITION

MIDDLE GROUND

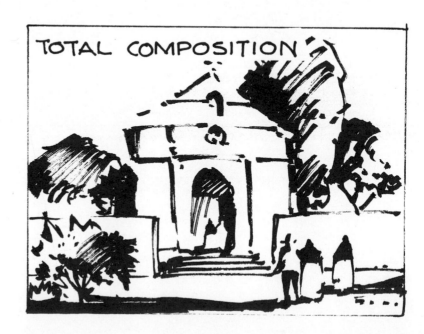

TOTAL COMPOSITION

THE TREE FORMS
THE BACKGROUND.

THE BUILDING
IS THE MIDDLE
GROUND.

TREES AND BUSHES STOP
ACTION OF ROAD AND BUILD-
ING OUT OF PICTURE.

LADDER
BRINGS
EYE AROUND
IN COMPOSI-
TION.

BUSHES AND
TREES BRING
EYE BACK
AROUND INTO
PICTURE.

WOMEN FACE
INTO CENTER
OF PICTURE.
THEY DIRECT
THE EYE IN-
WARD.

BACKGROUND
TREES SET
BUILDING OFF.

SHADOW AREA AND
FIGURES STOP EYE
ALONG ROAD AND KEEP
IT FROM LEAVING THE
PICTURE.

TREES, BUSHES, AND
SHADOWS ARE FORE-
GROUND.

CENTER OF INTEREST-
HIGH CONTRASTING
VALUES.

53

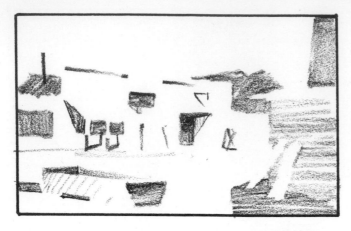

FIG. A. WHITES AND TONES

FIG. A. IS TOO SPOTTY ALTHOUGH THE WHITES ARE LINKED.

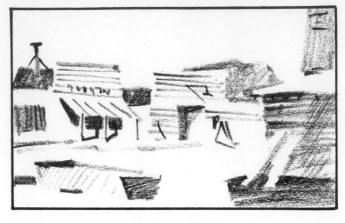

FIG A. COMPLETE

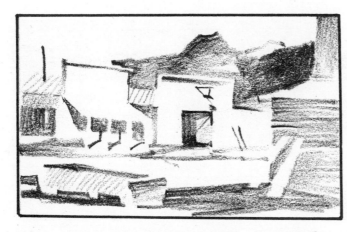

FIG. B. WHITES AND TONES

FIG. B. BOTH WHITES AND TONES ARE LINKED TO-GETHER BET-TER.

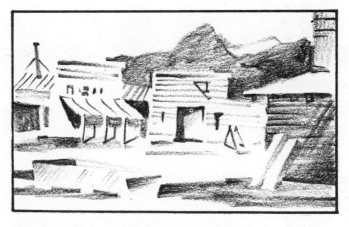

FIG. B. COMPLETE

IN COMPOSING A SKETCH, ONE MUST AVOID THE PITFALL OF SCATTER-ING THE WHITES AND TONES AROUND THE PICTURE FORMAT. THIS RESULTS IN A MONOTONOUS AND SPOTTY PICTURE. THE WHITES, MIDDLE TONES, AND DARKS SHOULD HAVE A LINKAGE ACROSS AND THROUGH THE COMPOSITION.

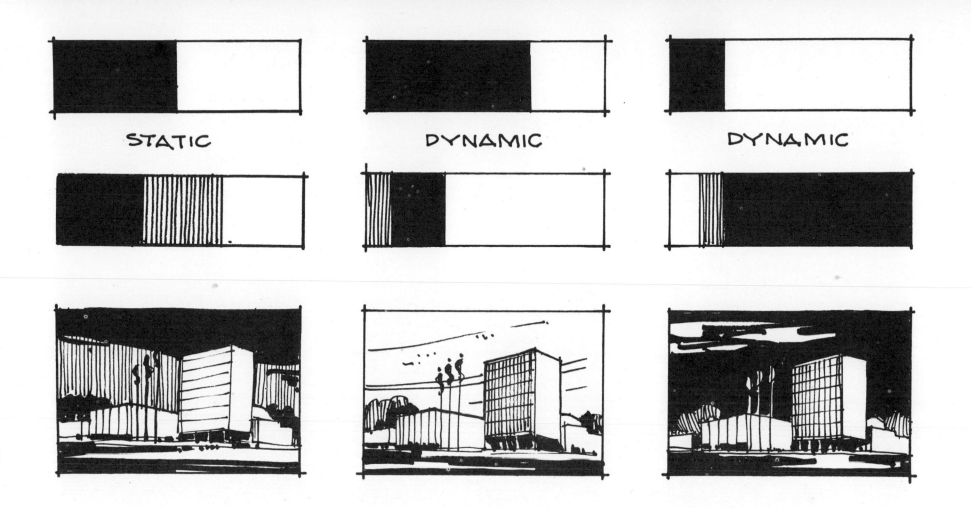

STATIC DYNAMIC DYNAMIC

A MORE INTERESTING COMPOSITION CAN BE DERIVED BY JUDICIOUSLY POSITIONING SHAPES IN A SKETCH.

THE SAME IS TRUE IN THE PROPORTIONATE USE OF BLACK, WHITE, AND MIDDLE TONE VALUES.

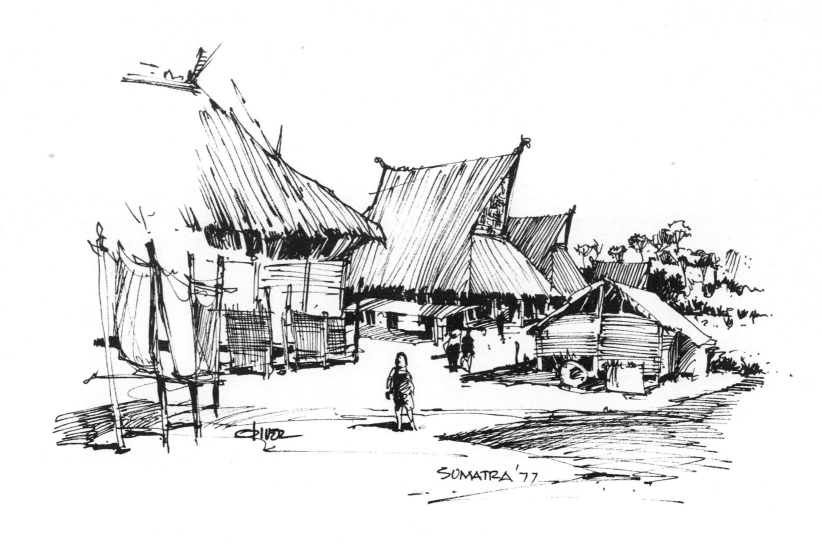

SUMATRA '77

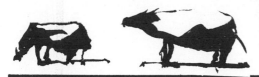 # PERSPECTIVE

ARCHITECTURAL SKETCHING CALLS UPON BOTH TWO-DIMENSIONAL AND THREE-DIMENSIONAL VIEWS TO COMMUNICATE GRAPHICALLY. HOWEVER, THREE-DIMENSIONAL SKETCHING INTRO-DUCES THE NEED FOR PER-SPECTIVE IN SKETCHES TO GIVE THEM REALITY.

IT SHOULD BE UNDERSTOOD THAT THERE ARE ONE-, TWO-, AND THREE-POINT PERSPECTIVE SYS-TEMS IN DRAWING. FOR MOST SKETCHING VIEWS, THE ONE- AND TWO-POINT PERSPECTIVE SYS-TEMS SHOULD SUFFICE. ONE SHOULD DEVELOP A FEELING FOR PERSPECTIVE SO ONE CAN APPLY THE THEORY OF LINES VANISH-ING TO A POINT WITHOUT THE USE OF AIDS.

UNTIL ONE DEVELOPS AN EYE FOR PERSPECTIVE, CHARTS CAN BE OF ASSISTANCE. BY DRAWING ON TRANSPARENT PAPER OVER THE CHARTS, USING THE LINES AS GUIDES, ONE CAN CONSTRUCT A SKETCH WITH REA-SONABLE CREDIBILITY.

OF COURSE, NOTHING CAN REPLACE THE FACILITY OF BEING ABLE TO THINK AND DRAW IN PERSPECT-IVE WITHOUT A CHART. IT IS IN-TENDED AS A QUICK TOOL BUT NOT A CRUTCH OR SUBSTITUTE.

PERSPECTIVE MEANS THAT EDGES

OF SOLIDS AND INTERIORS OF VOLUMES CONVERGE ON AN IMAGINARY POINT OR POINTS IN SPACE TO CREATE AN ILLUSION OF THREE DIMENSIONS.

PERSPECTIVES CAN BE VERY ACCURATELY PLOTTED TO RE-CONSTRUCT IN THREE DIMEN-SIONS THAT WHICH HAS BEEN CONCEIVED IN TWO DIMENSIONS. FOR SKETCHING, THIS PRECISION IS NOT NECESSARY, BUT AN UN-DERSTANDING OF PERSPECTIVE PRINCIPLES IS IMPORTANT AND ADVANTAGEOUS.

A FEW NOTES ON PERSPECTIVE

1. AS ONE OBSERVES THE SCENE, THERE IS AN IMAGINARY LINE DRAWN AT EYE LEVEL. THIS LINE IS KNOWN AS THE <u>HORIZON LINE</u>.

2. ALL LINES NOT PARALLEL TO AN IMAGINARY PLANE IN FRONT OF THE VIEWER WILL APPEAR TO RECEDE TO AN IMAGINARY POINT OF INFINITY ON THE HORIZON LINE. THIS POINT IS CALLED A <u>VANISHING POINT.</u> DEPENDING ON THE TYPE OF VIEW TAKEN, THERE MAY BE ONE OR TWO VANISHING POINTS.

3. ALL HORIZONTAL OR VERTICAL LINES IN FRONT OF THE VIEWER WILL APPEAR HORIZONTAL OR VERTICAL BUT WILL FORESHORTEN AS THEY RECEDE IN THE SCENE IN A ONE-POINT PERSPECTIVE. THIS APPLIES ONLY TO VERTICAL LINES IN A TWO-POINT PERSPECTIVE.

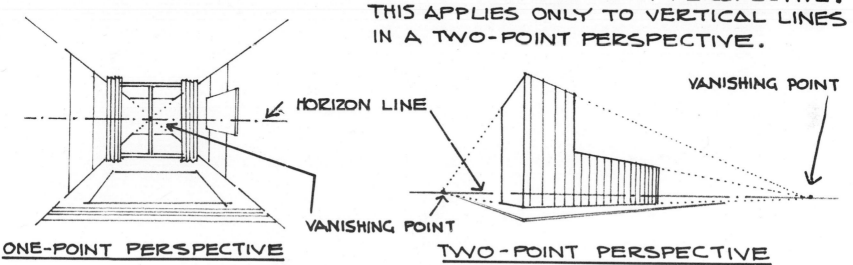

HORIZON LINE

VANISHING POINT

VANISHING POINT

ONE-POINT PERSPECTIVE

TWO-POINT PERSPECTIVE

BELOW IS THE SAME SCENE WHICH IS VIEWED FROM TWO DIFF-
ERENT POINTS. A ONE- OR TWO-POINT PERSPECTIVE WAS CALLED
FOR, DEPENDING UPON THE LOCATION OF THE VIEWER.

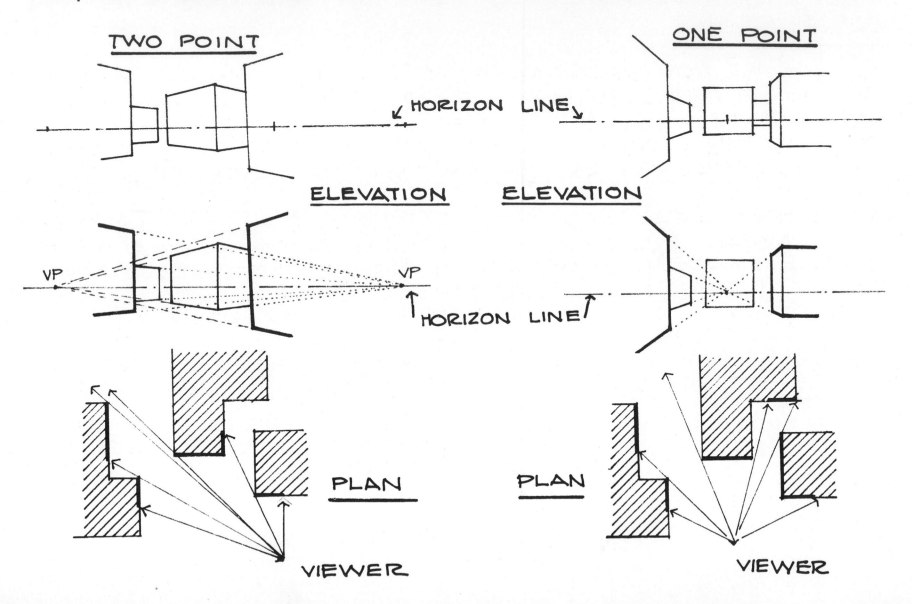

TWO POINT

ONE POINT

HORIZON LINE

ELEVATION

ELEVATION

VP

VP

HORIZON LINE

PLAN

PLAN

VIEWER

VIEWER

ONE-POINT PERSPECTIVE

LINES A.
ALL LINES THAT ARE PERPENDICULAR TO THE VIEWER WILL SLOPE TO THE VANISHING POINT.

VANISHING POINT

A

B

B

HORIZON LINE

B →

A

A

A

LINES B.
ALL LINES IN THE SCENE THAT ARE HORIZONTAL OR VERTICAL WILL RE-MAIN IN THAT FORM BUT WILL DIMINISH IN SIZE AS THEY RECEDE IN THE PICTURE.

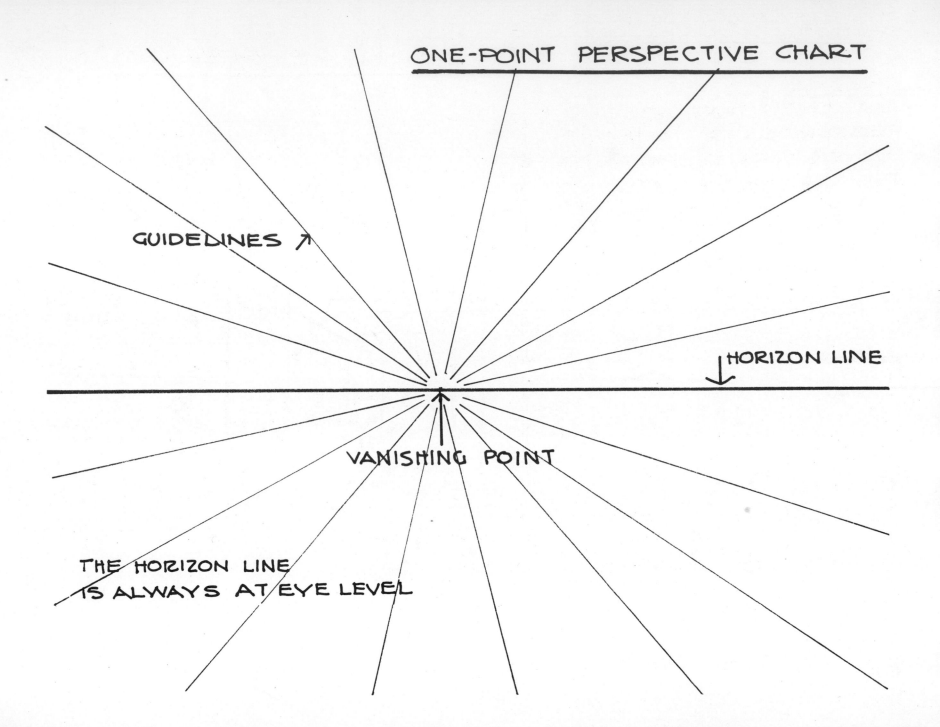

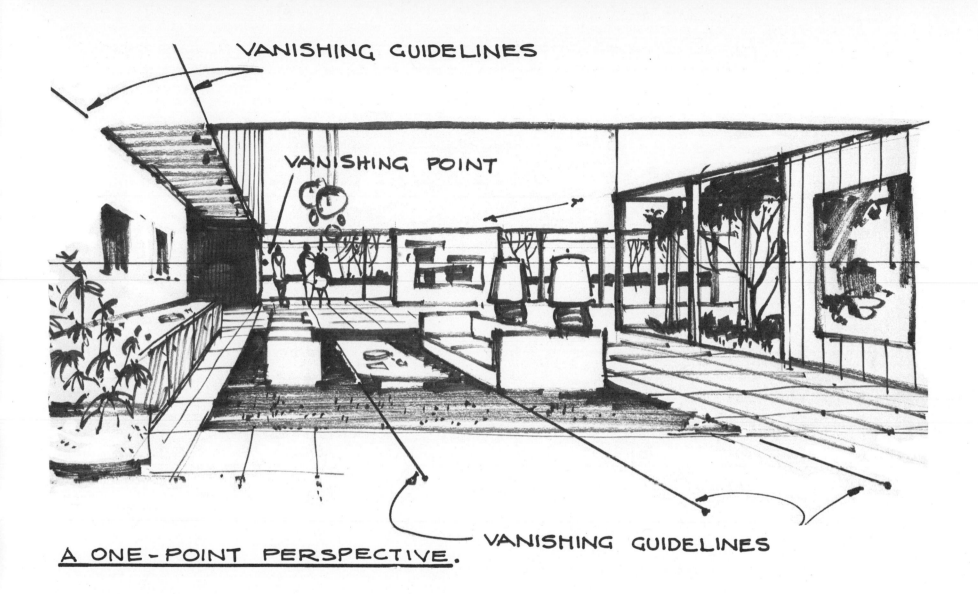

VANISHING GUIDELINES

VANISHING POINT

A ONE-POINT PERSPECTIVE.

VANISHING GUIDELINES

THIS SKETCH WAS CONSTRUCTED
OVER THE ONE-POINT PERSPEC-
TIVE CHART ON PAGE 62.

TWO-POINT PERSPECTIVE CHART 30°-60° VIEW

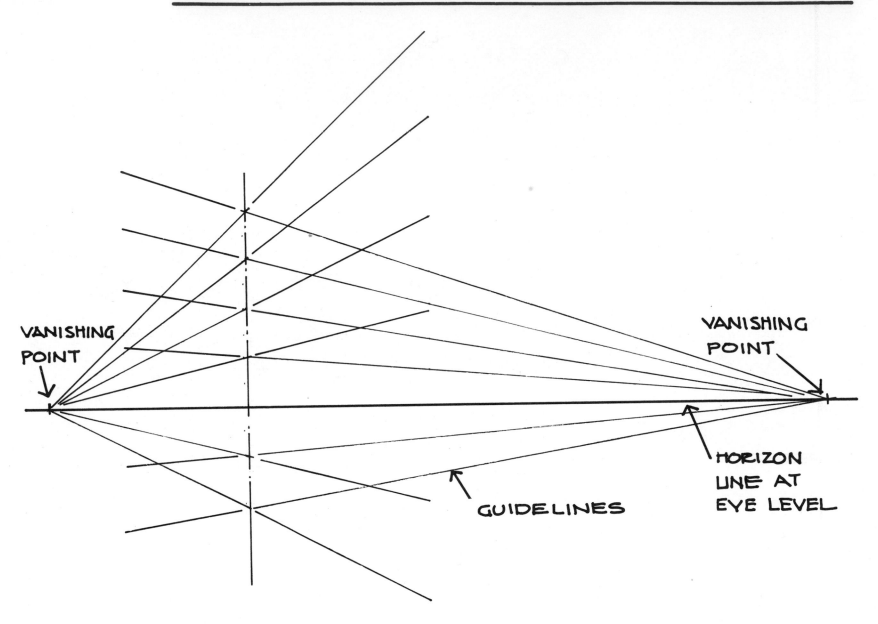

VANISHING
POINT

VANISHING
POINT

GUIDELINES

HORIZON
LINE AT
EYE LEVEL

LINES A.
ALL LINES IN THE SCENE THAT ARE HORIZONTAL WILL SLOPE TO ONE OF TWO VANISHING POINTS.

LINES B.
ALL LINES IN THE SCENE THAT ARE VERTICAL WILL REMAIN VERTICAL, BUT THEY WILL DIMINISH IN SIZE AS THEY RECEDE IN THE PICTURE.

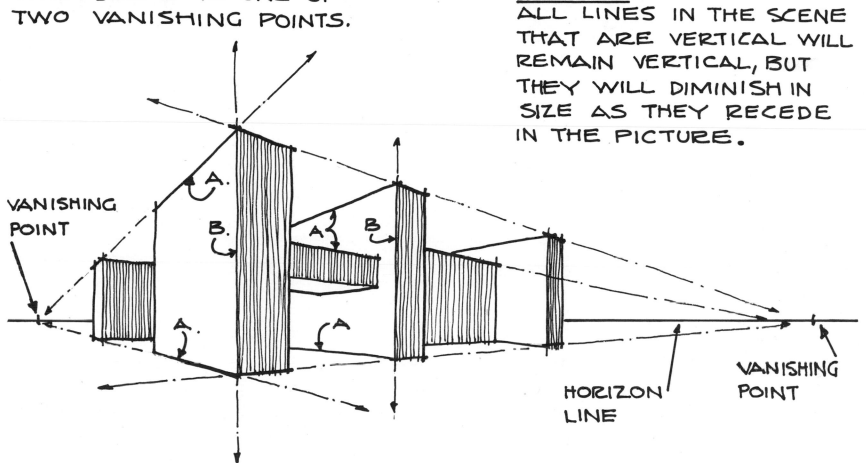

VANISHING POINT

A.

B.

A. B.

A.

A.

VANISHING POINT

HORIZON LINE

65

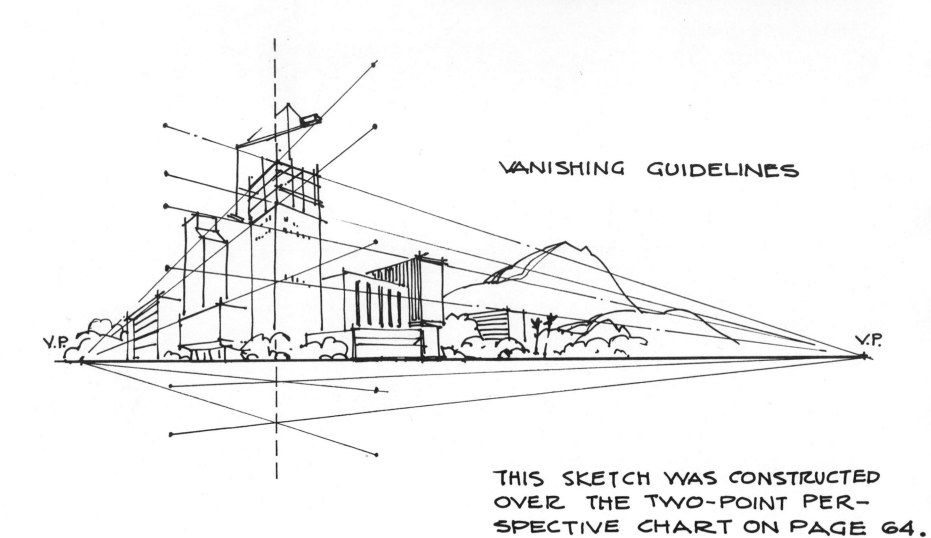

VANISHING GUIDELINES

V.P.

V.P.

THIS SKETCH WAS CONSTRUCTED
OVER THE TWO-POINT PER-
SPECTIVE CHART ON PAGE 64.

THUMBNAIL SKETCHES

THE THUMBNAIL SKETCH IS A
WAY TO RECORD IMPRESSIONS
IN VERY LOOSE AND BROAD
TERMS. IT IS A VERY GOOD
DEVICE FOR CONCEPTUALIZING.

DETAIL SHOULD NOT BE USED IN
EXECUTING THIS SKETCH. IT
SHOULD BE SIMPLE AND LOOSE.

MUCH IS SUGGESTED AND IM-
PLIED, WHICH IS THE SECRET OF
A GOOD THUMBNAIL SKETCH.

AS THE NAME SUGGESTS, THEY
ARE SMALL AND CAN BE EX-
ECUTED RAPIDLY.

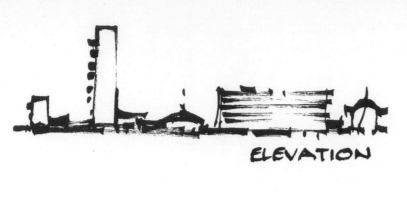

ELEVATION

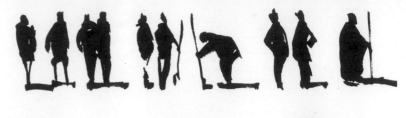

PLAN

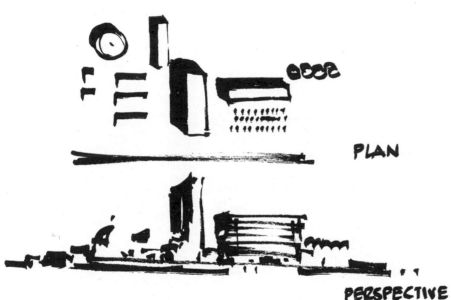

PERSPECTIVE

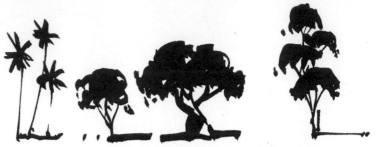

THUMBNAIL SKETCHING AS A FORM OF DOODLING IS VERY HELPFUL IN TRAINING THE EYE TO SEE PRO-PORTION. IT ALSO FORCES ONE TO KEEP THE SKETCH SIMPLE.

THE ABOVE SKETCHES ARE ACTUAL SIZE. THEY SHOW HOW ONE USES THE SHADE OR SHADOW OF AN OB-JECT TO QUICKLY ARRIVE AT A REPRESENTATION OF OBJECTS.

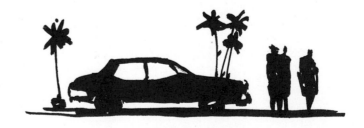

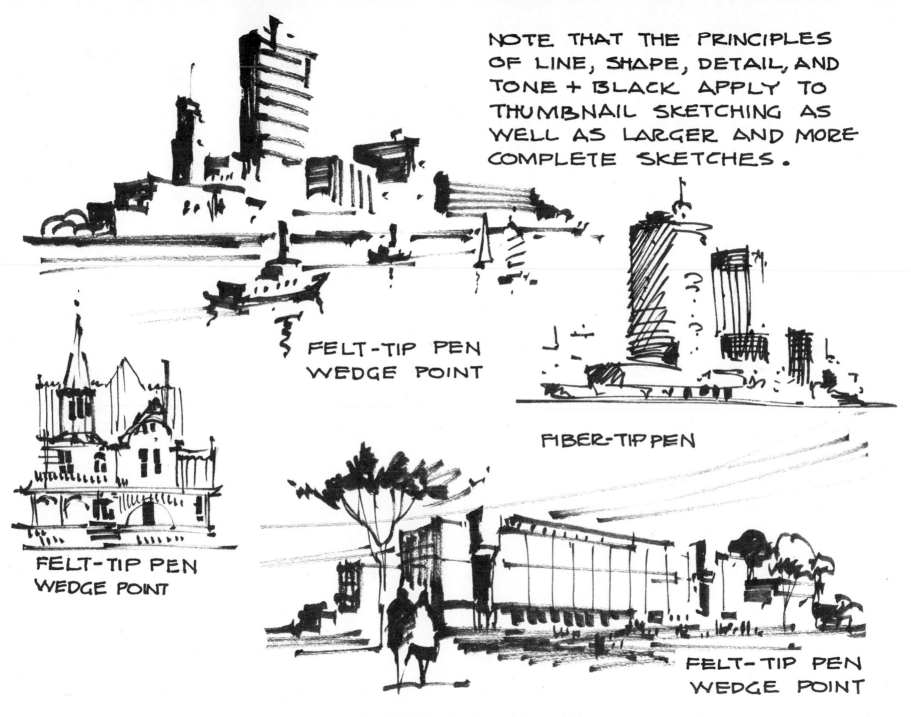

NOTE THAT THE PRINCIPLES OF LINE, SHAPE, DETAIL, AND TONE + BLACK APPLY TO THUMBNAIL SKETCHING AS WELL AS LARGER AND MORE COMPLETE SKETCHES.

FELT-TIP PEN WEDGE POINT

FIBER-TIP PEN

FELT-TIP PEN WEDGE POINT

FELT-TIP PEN WEDGE POINT

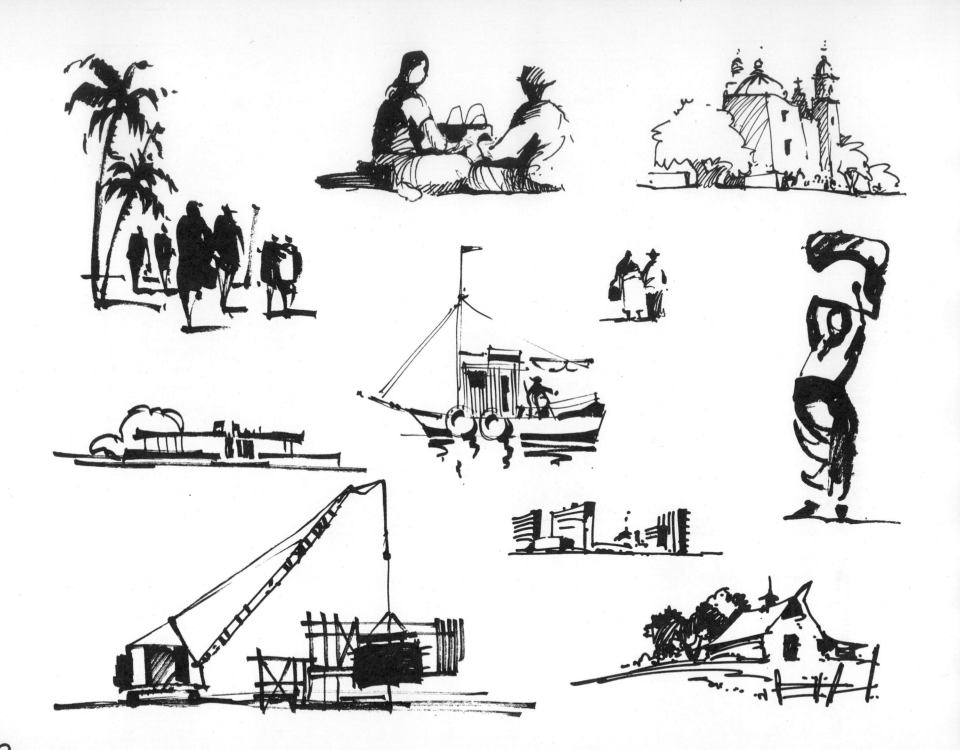

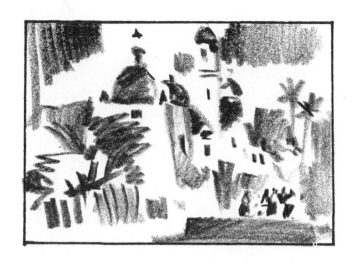

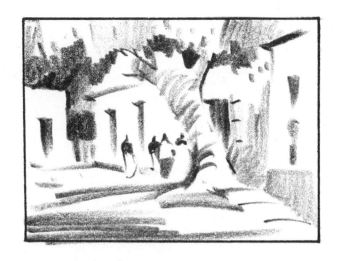

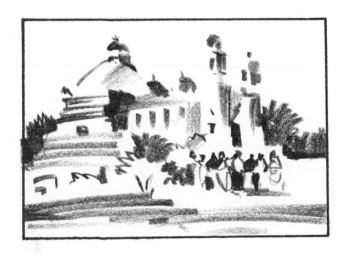

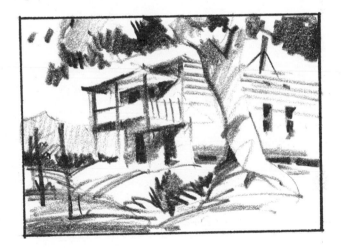

THE ABOVE THUMBNAIL SKETCHES WERE MADE AS COM-
POSITION AND VALUE STUDIES FOR LARGER DRAWINGS
AND PAINTINGS. THE SKETCHES ARE ACTUAL SIZE.

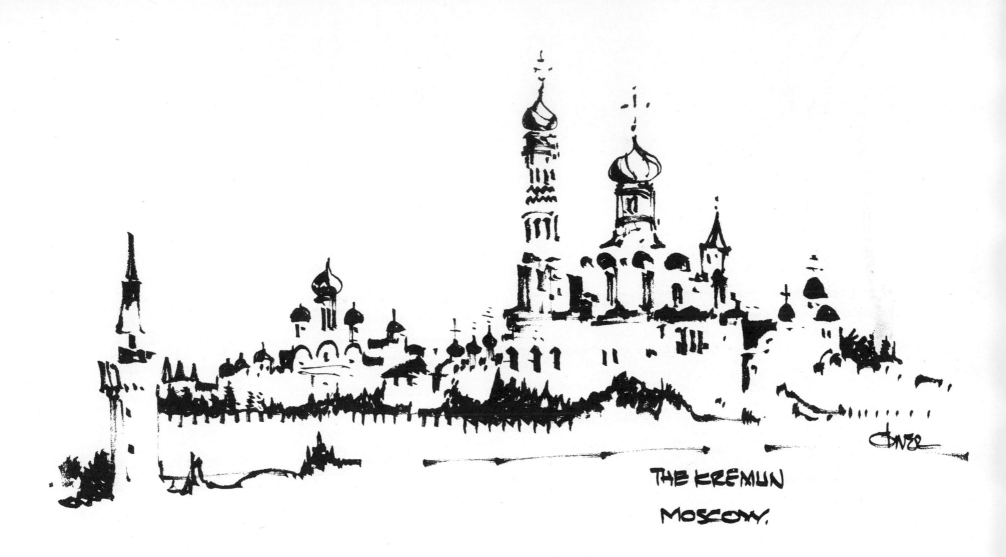

THE KREMLIN

MOSCOW.

FIGURES AND LANDSCAPE

FIGURES AND LANDSCAPE IN SKETCHES SERVE AN IMPORTANT ROLE. THEY PROVIDE SCALE TO A SCENE AND PROVIDE ANIMATION AND INTEREST.

THE OBJECTS NEED NOT BE PERFECT IN DETAIL. THEY SHOULD BE SKETCHY AND HAVE SOME PERSONALITY AND MOVEMENT.

THESE ELEMENTS IN A SKETCH ARE NOT TO BE CONFUSED WITH MORE PRECISE ONES OFTEN SEEN IN DETAILED DRAWINGS.

THE SUCCESS OF DRAWING GOOD FIGURES AND LANDSCAPE FEATURES DEPENDS ON KEEPING THEM SIMPLE WITH AUTHENTIC CHARACTERISTICS.

AS IN ALL SKETCHES, MUCH IS IMPLIED AND NOT NECESSARILY DRAWN.

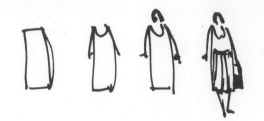

THE FIGURE CAN EVOLVE QUITE SIMPLY FROM A RECTANGULAR SHAPE CALLED A <u>TRUNK</u>.

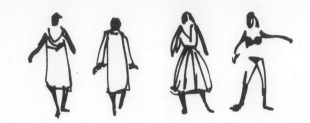

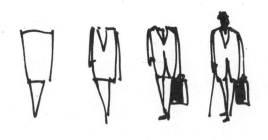

BY PLACING ARMS, LEGS, AND HEAD IN DIFFERENT ATTITUDES UPON THIS RECTANGULAR TRUNK SHAPE, THE FIGURE IS FORMED.

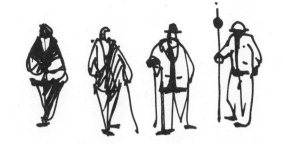

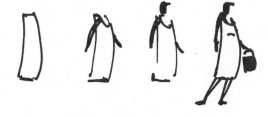

A FEW CLOTHING INDICATIONS AND ACCESSORIES GIVE MEANING TO THE FIGURE.

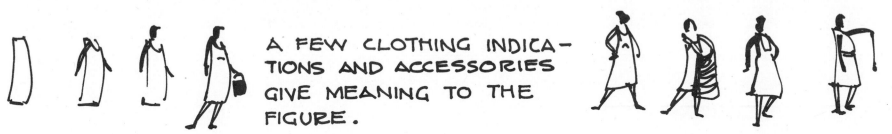

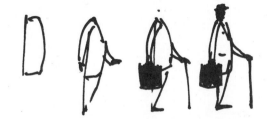

KEEP THE FIGURES SIMPLE.

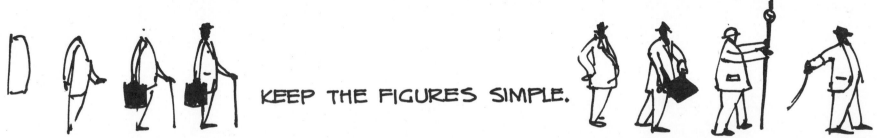

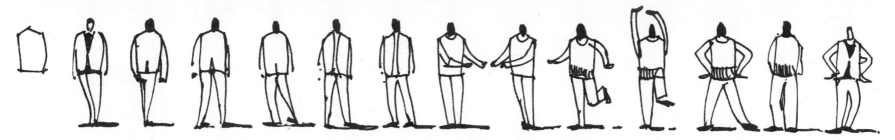

THE FIGURES SHOWN ABOVE AND BELOW ARE DEVELOPED
FROM THE SAME TRUNK SHAPE SHOWN ON THE LEFT. LEGS,
ARMS, AND FOOT DIRECTION PROVIDE DIRECTION AND ANIMATION
TO THE FIGURES.

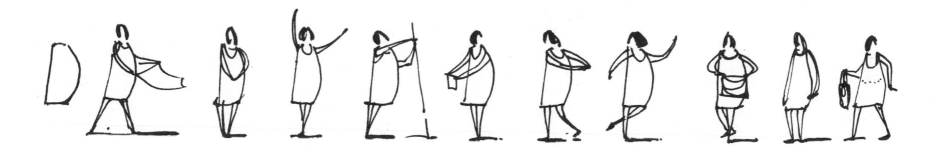

THE FIGURES SHOWN BELOW ARE SIMILAR TO THOSE ABOVE
BUT THEY HAVE MORE DETAIL ADDED TO THEIR COSTUME TO
PROVIDE MORE INTEREST.

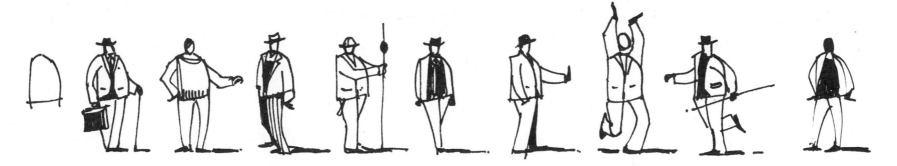

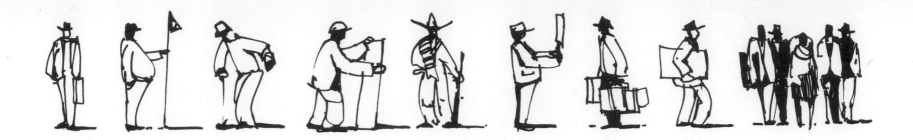

THE FIGURES ON THIS PAGE WERE MADE
FROM THE SAME BASIC TRUNK FORM. TO
PROVIDE MORE ANIMATION TO THE FIGURE, THE
TRUNK WAS CURVED INSTEAD OF RECTILINEAR
AS IN PREVIOUS EXAMPLES. THE ATTITUDES OF
THE ARMS, LEGS, AND HEAD PROVIDE ACTION
AND DIRECTION TO THE FIGURES.

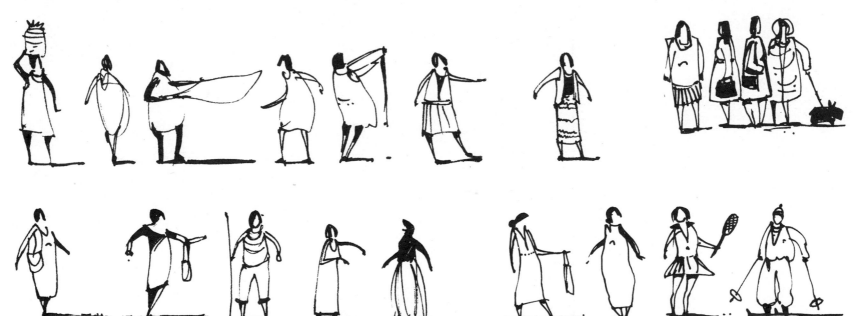

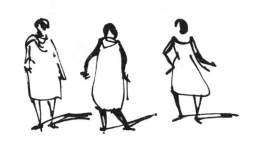

FINE FIBER-TIP PEN

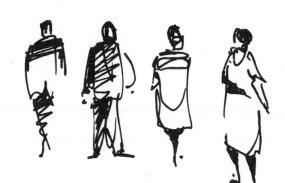
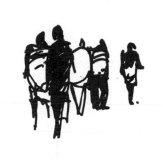
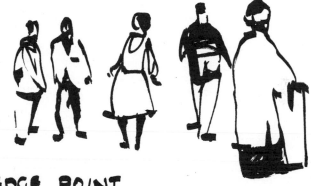

WEDGE POINT
FELT-TIP PEN

MEDIUM FIBER-TIP PEN.

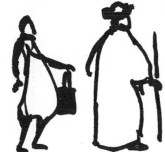
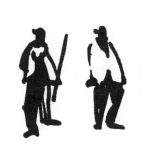

LARGER THAN NORMAL FELT-TIP PEN

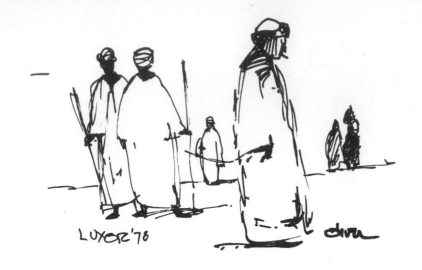

LUXOR '78

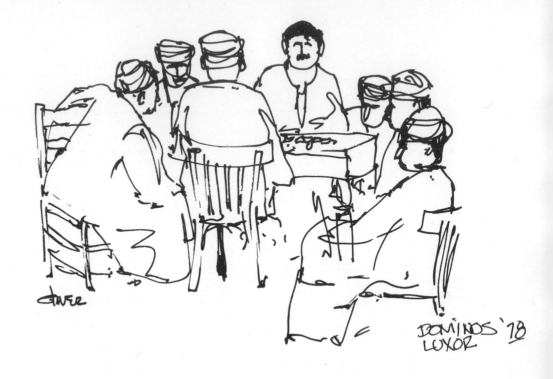

DOMINOS '78
LUXOR

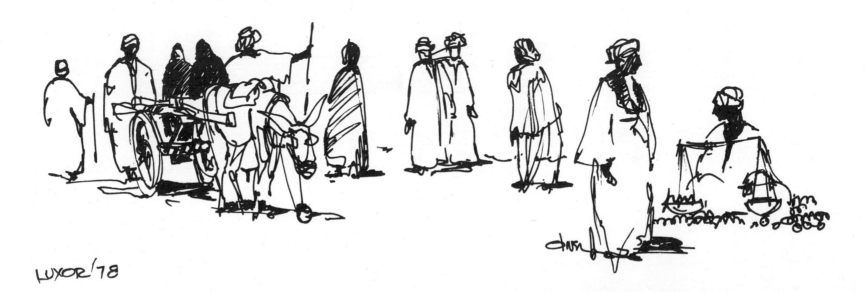

LUXOR '78

78

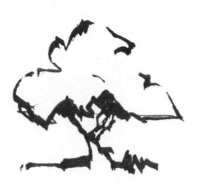
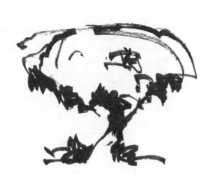
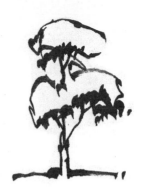

NOTE THE STRONG EMPHASIS ON THE SHADE AND SHADOW AREAS OF THE FOLIAGE AND TRUNK

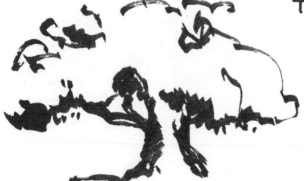
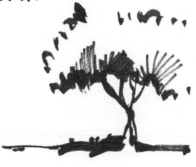
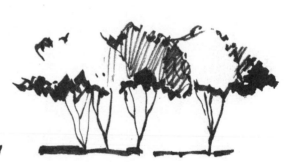

LEAVE THE SUNLIT AREAS SKETCHY.

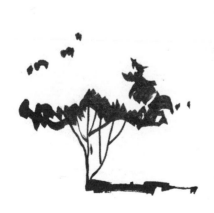
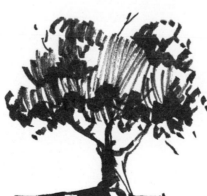
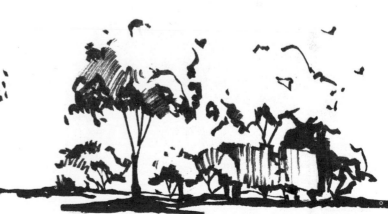

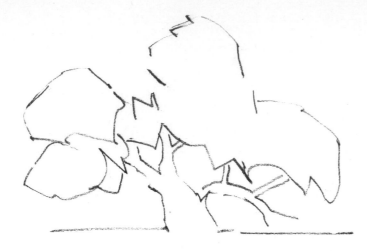

BLOCK OUT FOLIAGE AND
TRUNK SHAPE.

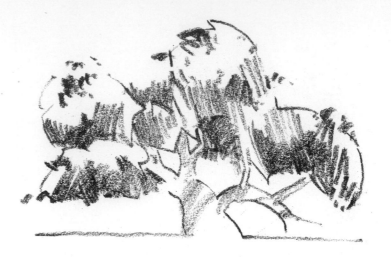

APPLY LIGHT AND MIDDLE
VALUE TONES IN SHADED
AREAS OF FOLIAGE AND
TREE TRUNK. LEAVE THE
AREAS WHERE SUN HITS
ALMOST WITHOUT TONE.

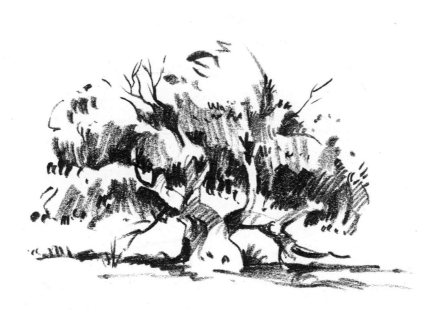

APPLY DARK TONES + BLACK.
INTRODUCE DETAIL OF
BRANCHES AND LEAF
STRUCTURE.

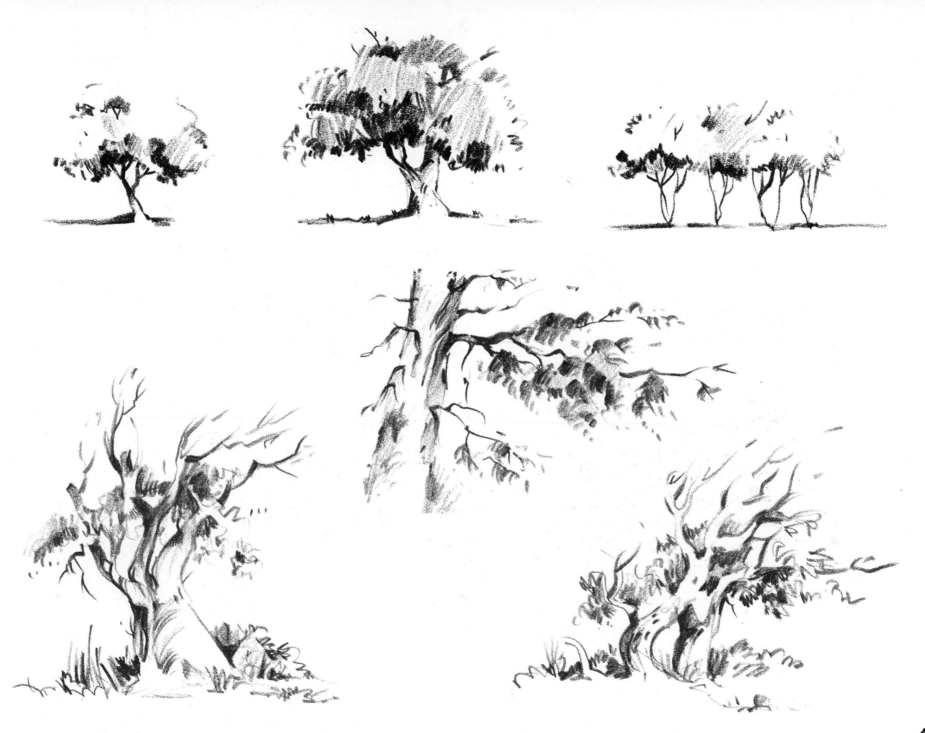

81

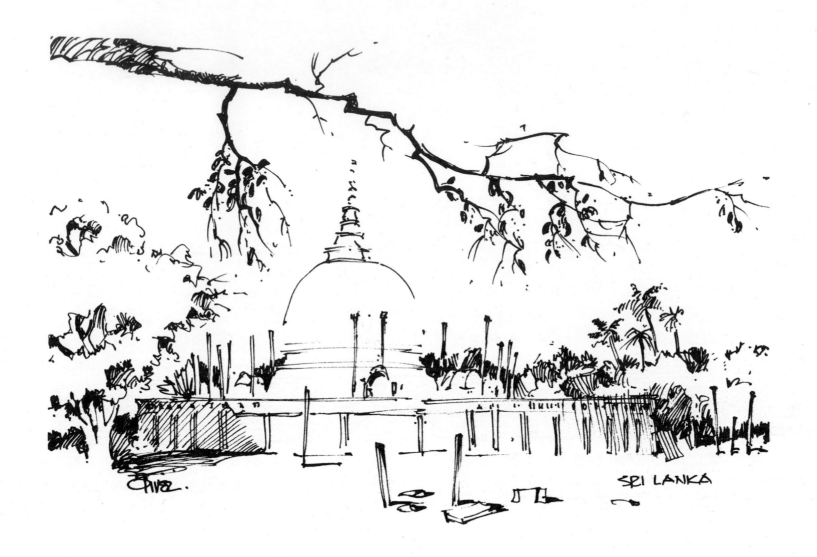

SRI LANKA

82

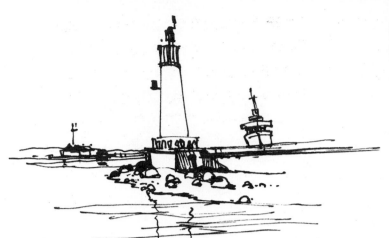

EXAMPLES AND CRITIQUE

THE EXAMPLES APPEARING ON THE FOLLOWING PAGES ILLUSTRATE THE USE OF DIFFERENT DRAWING TOOLS IN SKETCHING.

MORE IMPORTANT, HOWEVER, ARE THE NOTES ON EACH SKETCH THAT CALL ATTENTION TO THE VARIOUS AREAS THAT MAKE THE SKETCH EFFECTIVE.

IT IS SUGGESTED THAT ONE COPY EACH SKETCH. IN DOING SO, ONE SHOULD OBSERVE HOW THE VARIOUS AREAS AND THEIR HANDLING CONTRIBUTE TO THE SUCCESS OF THE SKETCH.

THIS IS AN INVALUABLE WAY TO LEARN, PROVIDING ONE IS AWARE OF WHAT IS HAPPENING AND WHY.

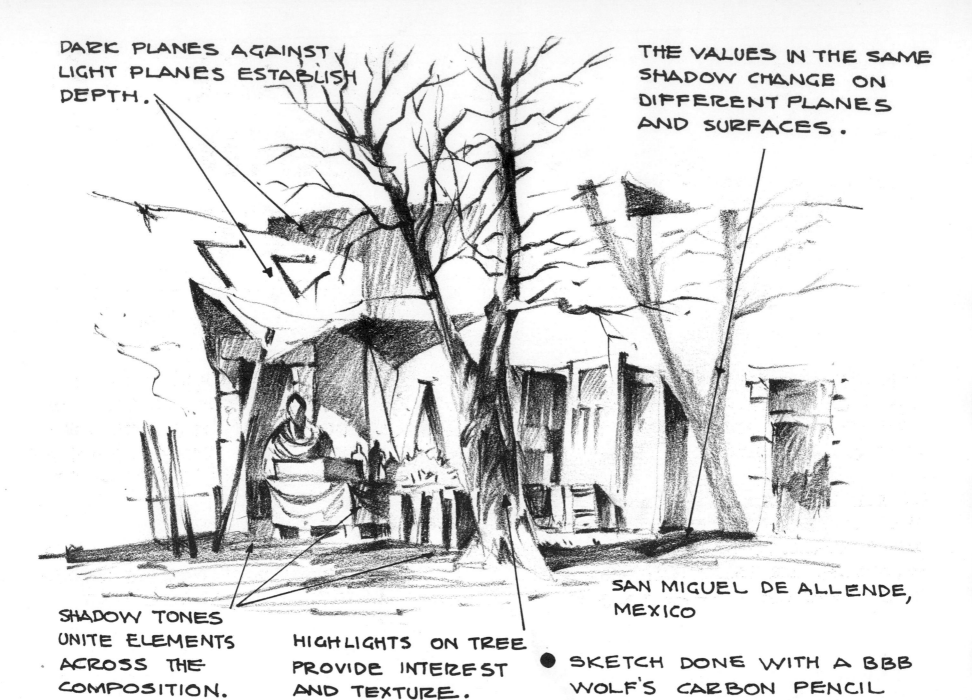

DARK PLANES AGAINST LIGHT PLANES ESTABLISH DEPTH.

THE VALUES IN THE SAME SHADOW CHANGE ON DIFFERENT PLANES AND SURFACES.

SHADOW TONES UNITE ELEMENTS ACROSS THE COMPOSITION.

HIGHLIGHTS ON TREE PROVIDE INTEREST AND TEXTURE.

SAN MIGUEL DE ALLENDE, MEXICO

● SKETCH DONE WITH A BBB WOLF'S CARBON PENCIL

84

A GOOD EXAMPLE OF PLAYING
DARKS AGAINST LIGHTS TO
ESTABLISH FORM. A MINIMUM
OF LINES IS USED.

MOST ACTIVITY IN VALUES
IS LOCATED IN THE CENTER
OF INTEREST.

SAN MIGUEL DE ALLENDE,
MEXICO.

ELEMENTS IN
THE FOREGROUND
TIE ACROSS THE
COMPOSITION.

● SKETCH DONE WITH A 6-B
"L & C HARDMUTH" PENCIL - SQUARE
LEAD.

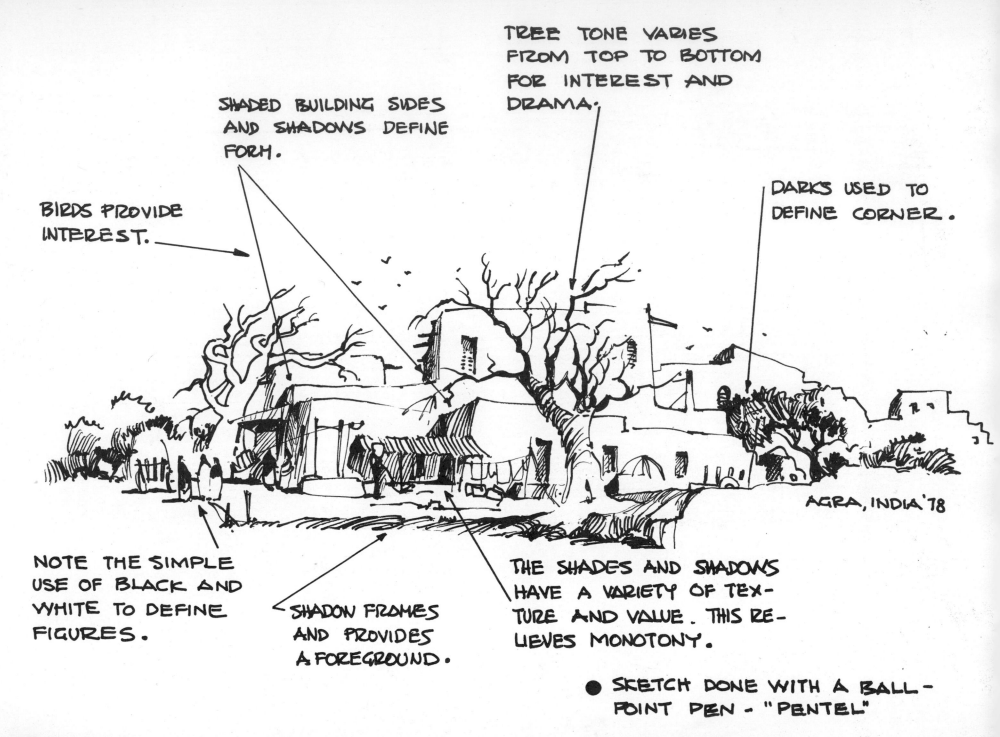

BIRDS PROVIDE
INTEREST.

SHADED BUILDING SIDES
AND SHADOWS DEFINE
FORM.

TREE TONE VARIES
FROM TOP TO BOTTOM
FOR INTEREST AND
DRAMA.

DARKS USED TO
DEFINE CORNER.

AGRA, INDIA '78

NOTE THE SIMPLE
USE OF BLACK AND
WHITE TO DEFINE
FIGURES.

SHADOW FRAMES
AND PROVIDES
A FOREGROUND.

THE SHADES AND SHADOWS
HAVE A VARIETY OF TEX-
TURE AND VALUE. THIS RE-
LIEVES MONOTONY.

● SKETCH DONE WITH A BALL-
POINT PEN - "PENTEL"

86

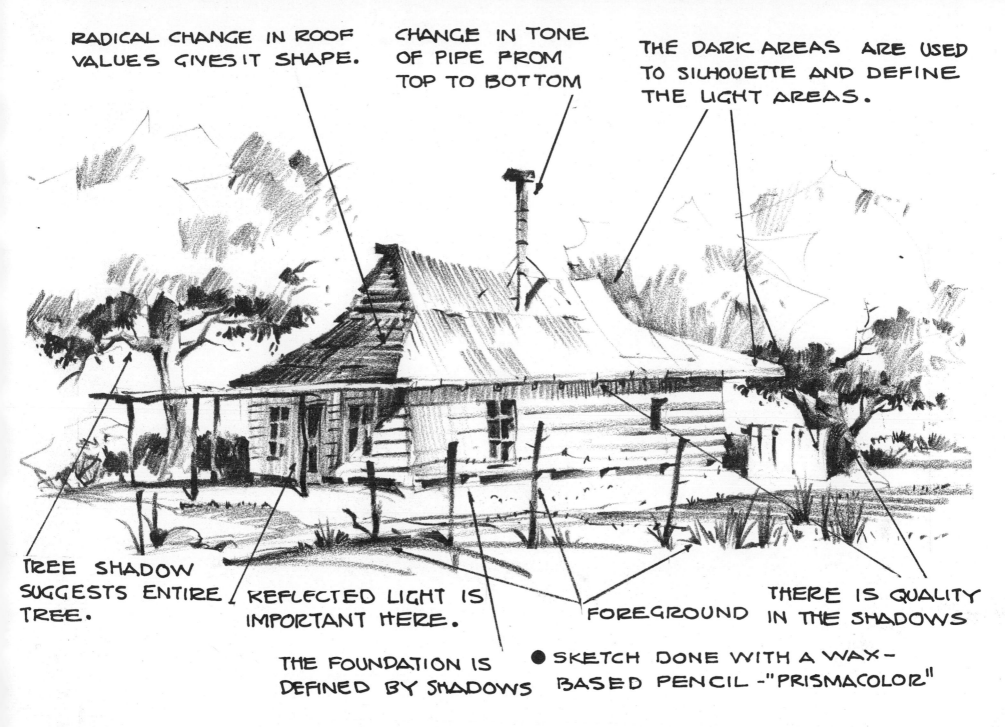

RADICAL CHANGE IN ROOF VALUES GIVES IT SHAPE.

CHANGE IN TONE OF PIPE FROM TOP TO BOTTOM

THE DARK AREAS ARE USED TO SILHOUETTE AND DEFINE THE LIGHT AREAS.

TREE SHADOW SUGGESTS ENTIRE TREE.

REFLECTED LIGHT IS IMPORTANT HERE.

FOREGROUND

THERE IS QUALITY IN THE SHADOWS

THE FOUNDATION IS DEFINED BY SHADOWS

● SKETCH DONE WITH A WAX-BASED PENCIL -"PRISMACOLOR"

87

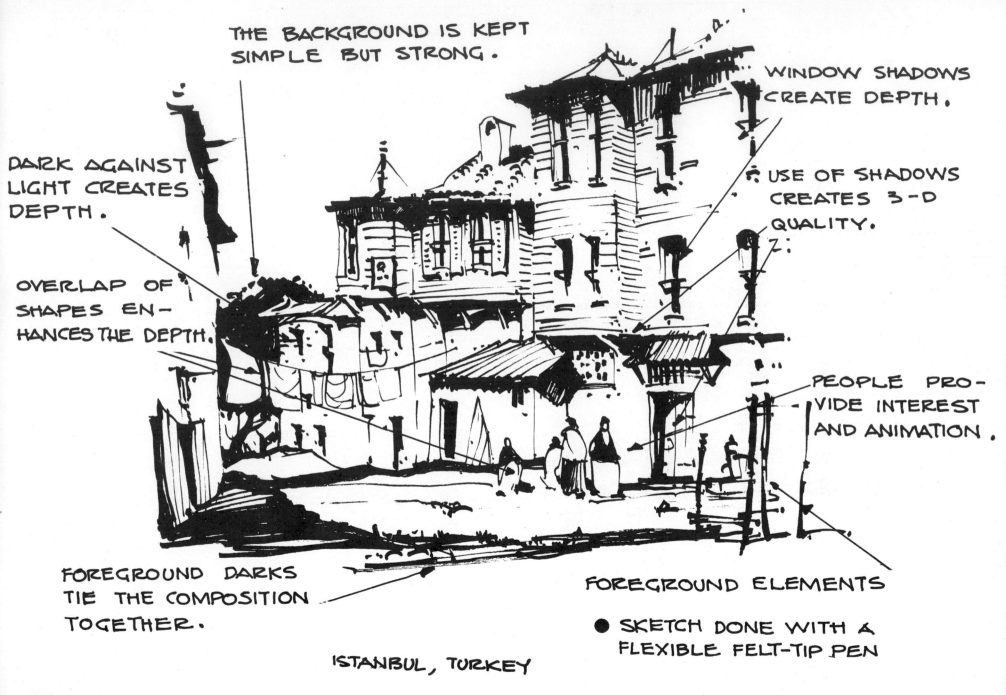

THE BACKGROUND IS KEPT SIMPLE BUT STRONG.

WINDOW SHADOWS CREATE DEPTH.

DARK AGAINST LIGHT CREATES DEPTH.

USE OF SHADOWS CREATES 3-D QUALITY.

OVERLAP OF SHAPES EN- HANCES THE DEPTH.

PEOPLE PRO- VIDE INTEREST AND ANIMATION.

FOREGROUND DARKS TIE THE COMPOSITION TOGETHER.

FOREGROUND ELEMENTS

● SKETCH DONE WITH A FLEXIBLE FELT-TIP PEN

ISTANBUL, TURKEY

88

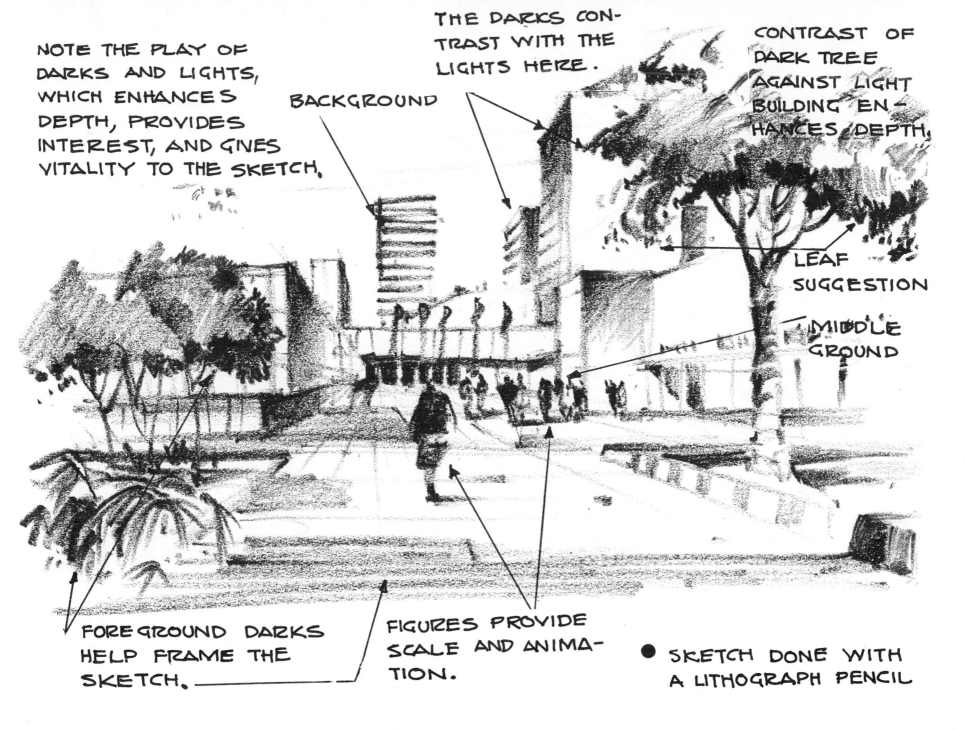

NOTE THE PLAY OF DARKS AND LIGHTS, WHICH ENHANCES DEPTH, PROVIDES INTEREST, AND GIVES VITALITY TO THE SKETCH.

THE DARKS CONTRAST WITH THE LIGHTS HERE.

CONTRAST OF DARK TREE AGAINST LIGHT BUILDING ENHANCES DEPTH.

BACKGROUND

LEAF SUGGESTION

MIDDLE GROUND

FOREGROUND DARKS HELP FRAME THE SKETCH.

FIGURES PROVIDE SCALE AND ANIMATION.

● SKETCH DONE WITH A LITHOGRAPH PENCIL

89

PENCIL STROKES
ARE MOST
IMPORTANT
TO MAKE
SHADED
AREAS
MORE IN-
TERESTING.

SHADOWS ARE
IMPORTANT TO
GIVE A SENSE
OF DEPTH IN
THE SKETCH.

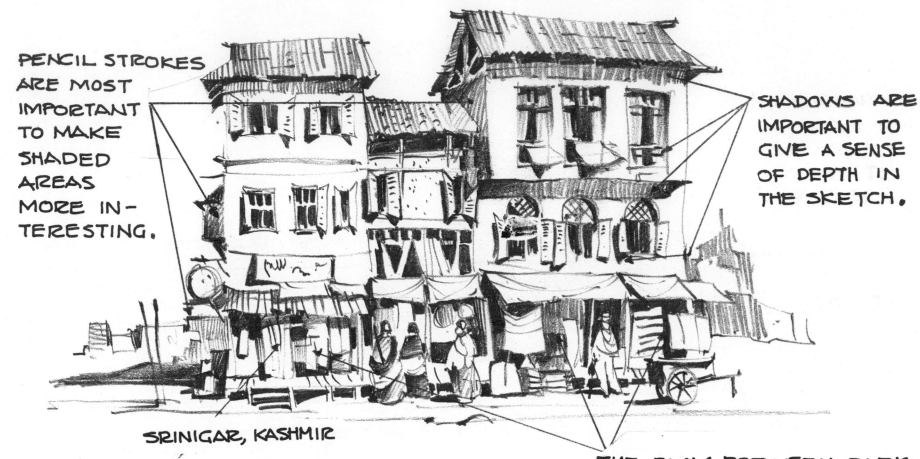

SRINIGAR, KASHMIR

FEW LINES ARE DRAWN.
THE FORM AND SHAPE IS
CREATED BY HAVING ONE
TONE PLAY OFF AGAINST
ANOTHER.

THE PLAY BETWEEN DARK
AND LIGHT AREAS TO DE-
FINE SHAPES IS IMPORTANT
HERE.

● SKETCH DONE WITH A
SOFT SKETCH PENCIL
"EBONY JET BLACK"

VARY THE WIDTH OF THE
STROKE TO PROVIDE
INTEREST AND TEXTURE

TREES AND
RAINSPOUTS
PROVIDE FRAME
AT TOP OF FORMAT.

PLACE SOME
AUTHENTIC
ELEMENTS IN
THE SKETCH
SUCH AS
LIGHTS, SPOUTS
AND PEOPLE.

STREET FOCUSES
ATTENTION ON THE
CENTER OF INTEREST

THE CENTER OF
INTEREST HAS
MUCH ACTIVITY OF
VALUES.

MEXICAN VILLAGE

SHADOW FRAMES AND
STOPS ACTION OUT OF PICTURE

● SKETCH DONE WITH A FINE
LEAD MECHANICAL PENCIL

91

THIS MEDIUM IS VERY RESPONSIVE TO THE SURFACE TEXTURE OF THE PAPER.

PENCIL STROKES ARE USED TO SUGGEST ACTUAL BUILD- ING MATERIALS.

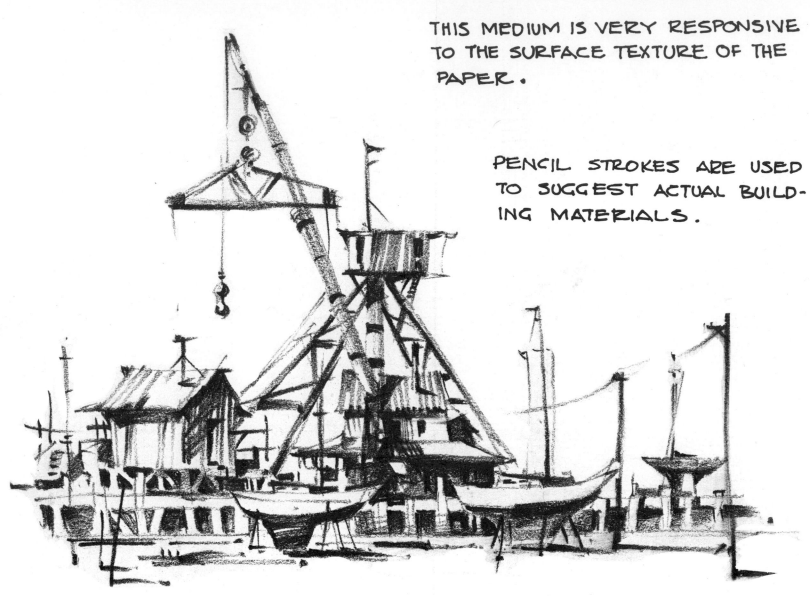

NEWPORT BOAT YARD

● SKETCH DONE WITH A "CONTÉ" CHARCOAL DRAWING PENCIL

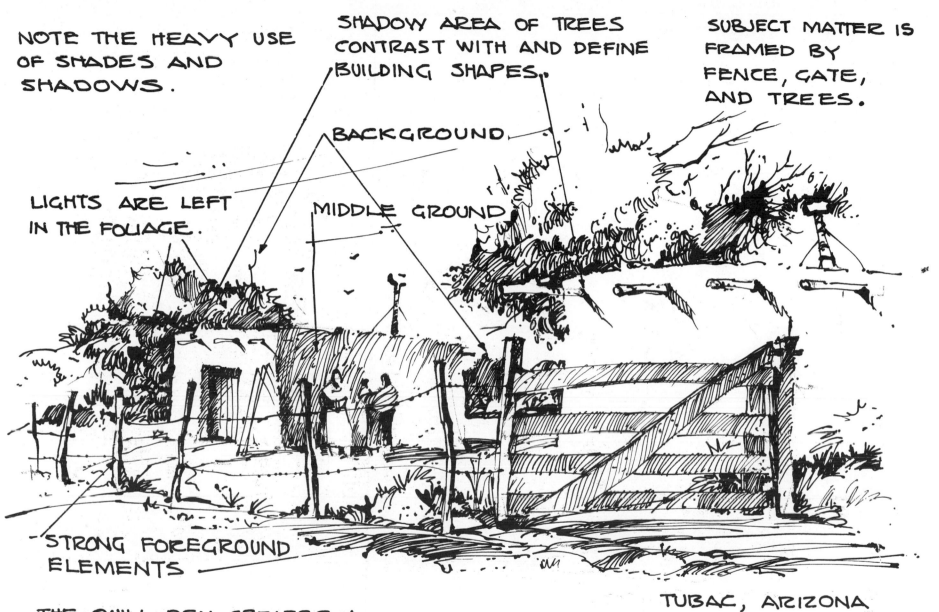

NOTE THE HEAVY USE OF SHADES AND SHADOWS.

SHADOWY AREA OF TREES CONTRAST WITH AND DEFINE BUILDING SHAPES.

SUBJECT MATTER IS FRAMED BY FENCE, GATE, AND TREES.

BACKGROUND

LIGHTS ARE LEFT IN THE FOLIAGE.

MIDDLE GROUND

STRONG FOREGROUND ELEMENTS

THE QUILL PEN CREATES A UNIQUE QUALITY IN THE SKETCH UNLIKE OTHER MORE RIGID POINTS.

TUBAC, ARIZONA

● SKETCH DONE WITH AN "ESTERBROOK" QUILL PEN

THIS IS A FREE-FLOWING
QUICK SKETCH DUE TO
THE NATURE OF THE PEN.

REPETITION OF TEXTURES
PROVIDES INTEREST AND
CONTINUITY.

NOTHING IS TOO DETAILED.

LIGHTS LEFT
IN DARK
SHADOWS.

INTEREST AREA
BALANCES LARGE
ELEMENTS ACROSS
THE COMPOSITION.

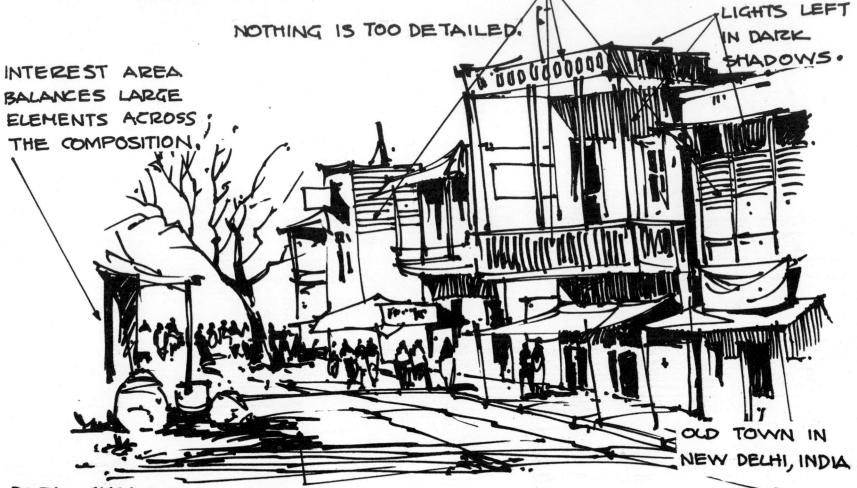

OLD TOWN IN
NEW DELHI, INDIA

DARK SHADOW FRAMES,
TIES ACROSS, AND STOPS
THE ACTION OUT OF THE
FORMAT.

● SKETCH DONE WITH A
"FW FREELINER" INDIA INK
CARTRIDGE PEN

94

MUCH IS LEFT TO THE
IMAGINATION OF THE
VIEWER.

THE SKETCH DEMONSTRATES
THE EFFECTIVENESS OF
VALUES AND TONES.

LINES ARE AT A MINIMUM.
TONES DEFINE THE SHAPES.

A VERY QUICK TECHNIQUE,
BUT IT TAKES A BIT OF
SKILL.

● SKETCH DONE WITH A LITHOGRAPH
WAX CRAYON STICK DRAWN ON
ITS SIDE ACROSS THE SURFACE

NOTE THE VERY LOOSE
HANDLING AND VERY
BRIEF SUGGESTION OF
TREES, PEOPLE, AND
BUILDINGS.

INTEREST IS PROVIDED BY
PLAY OF DARKS AND LIGHTS.

PEOPLE PRO-
VIDE SCALE
AND ANIMATION.

FOREGROUND
ELEMENTS

SHADOW STOPS
THE ACTION FROM
FLOWING OUT OF
FORMAT.

● SKETCH DONE WITH A "CONTÉ"
CRAYON STICK AND A FIBER-
TIP PEN

96

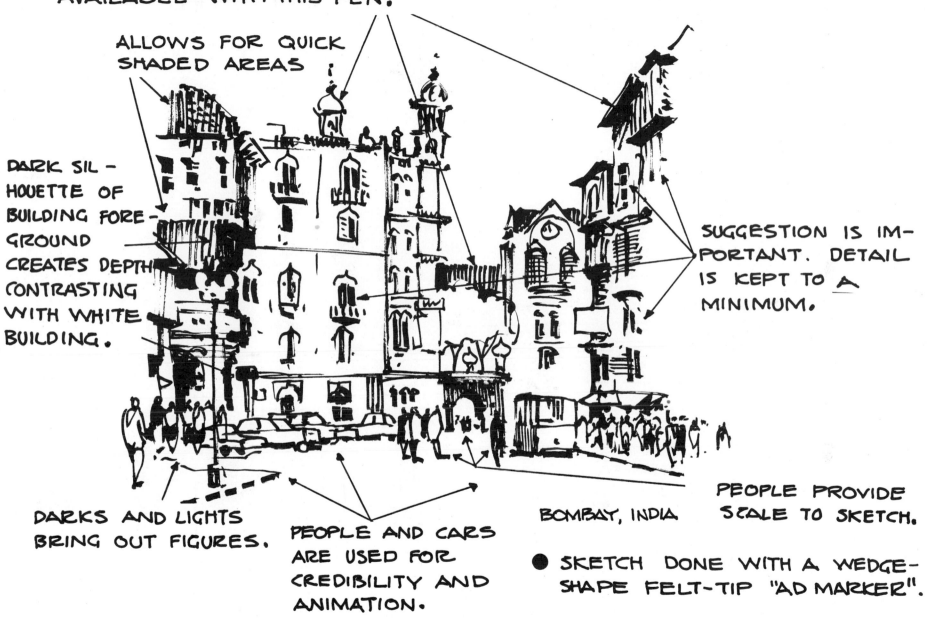

NOTE THE VARIOUS LINE WEIGHTS AVAILABLE WITH THIS PEN.

ALLOWS FOR QUICK SHADED AREAS

DARK SIL-HOUETTE OF BUILDING FORE-GROUND CREATES DEPTH CONTRASTING WITH WHITE BUILDING.

SUGGESTION IS IM-PORTANT. DETAIL IS KEPT TO A MINIMUM.

DARKS AND LIGHTS BRING OUT FIGURES.

PEOPLE AND CARS ARE USED FOR CREDIBILITY AND ANIMATION.

BOMBAY, INDIA

PEOPLE PROVIDE SCALE TO SKETCH.

● SKETCH DONE WITH A WEDGE-SHAPE FELT-TIP "AD MARKER".

97

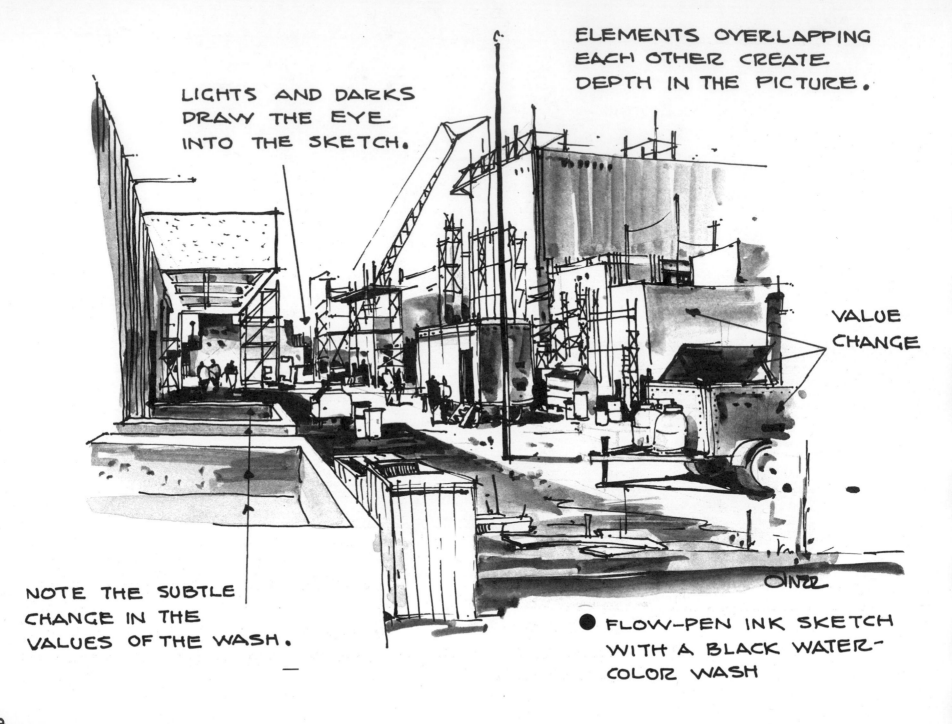

LIGHTS AND DARKS
DRAW THE EYE
INTO THE SKETCH.

ELEMENTS OVERLAPPING
EACH OTHER CREATE
DEPTH IN THE PICTURE.

VALUE
CHANGE

NOTE THE SUBTLE
CHANGE IN THE
VALUES OF THE WASH.

● FLOW-PEN INK SKETCH
WITH A BLACK WATER-
COLOR WASH

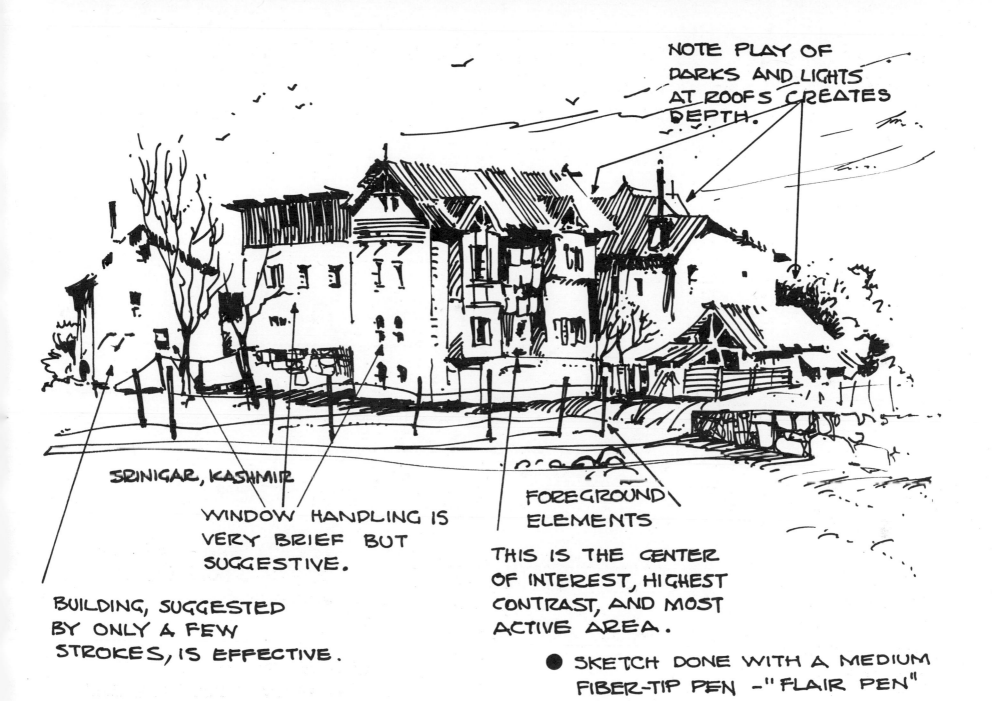

NOTE PLAY OF
DARKS AND LIGHTS
AT ROOFS CREATES
DEPTH.

SRINIGAR, KASHMIR

WINDOW HANDLING IS
VERY BRIEF BUT
SUGGESTIVE.

FOREGROUND
ELEMENTS

THIS IS THE CENTER
OF INTEREST, HIGHEST
CONTRAST, AND MOST
ACTIVE AREA.

BUILDING, SUGGESTED
BY ONLY A FEW
STROKES, IS EFFECTIVE.

● SKETCH DONE WITH A MEDIUM
FIBER-TIP PEN – "FLAIR PEN"

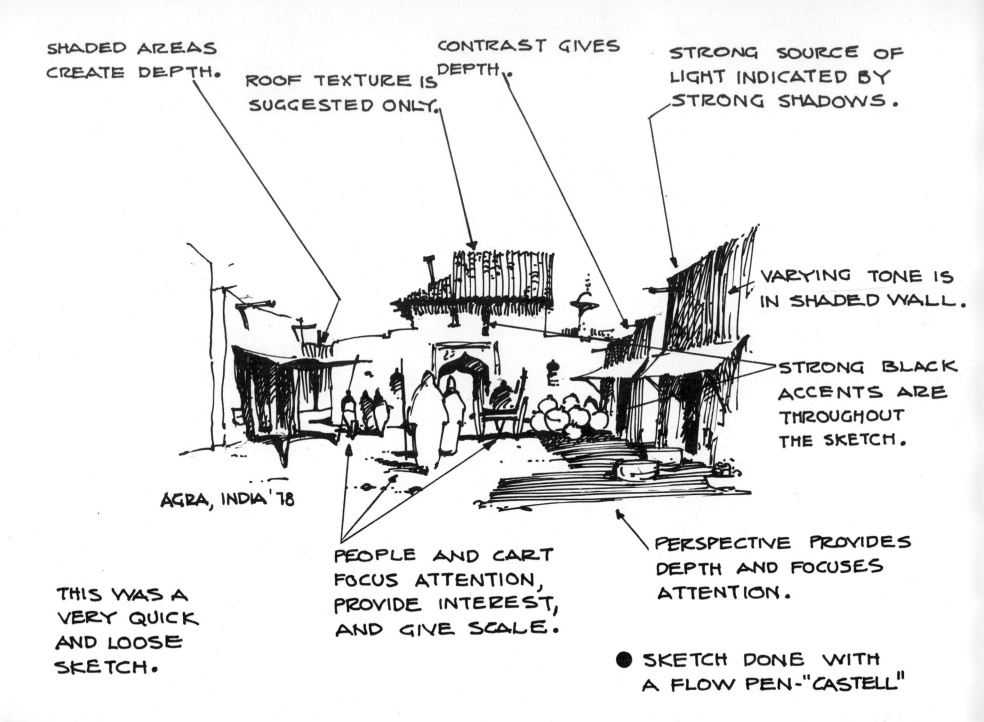

SHADED AREAS
CREATE DEPTH.

ROOF TEXTURE IS
SUGGESTED ONLY.

CONTRAST GIVES
DEPTH.

STRONG SOURCE OF
LIGHT INDICATED BY
STRONG SHADOWS.

VARYING TONE IS
IN SHADED WALL.

STRONG BLACK
ACCENTS ARE
THROUGHOUT
THE SKETCH.

AGRA, INDIA '78

PEOPLE AND CART
FOCUS ATTENTION,
PROVIDE INTEREST,
AND GIVE SCALE.

PERSPECTIVE PROVIDES
DEPTH AND FOCUSES
ATTENTION.

THIS WAS A
VERY QUICK
AND LOOSE
SKETCH.

● SKETCH DONE WITH
A FLOW PEN-"CASTELL"

100

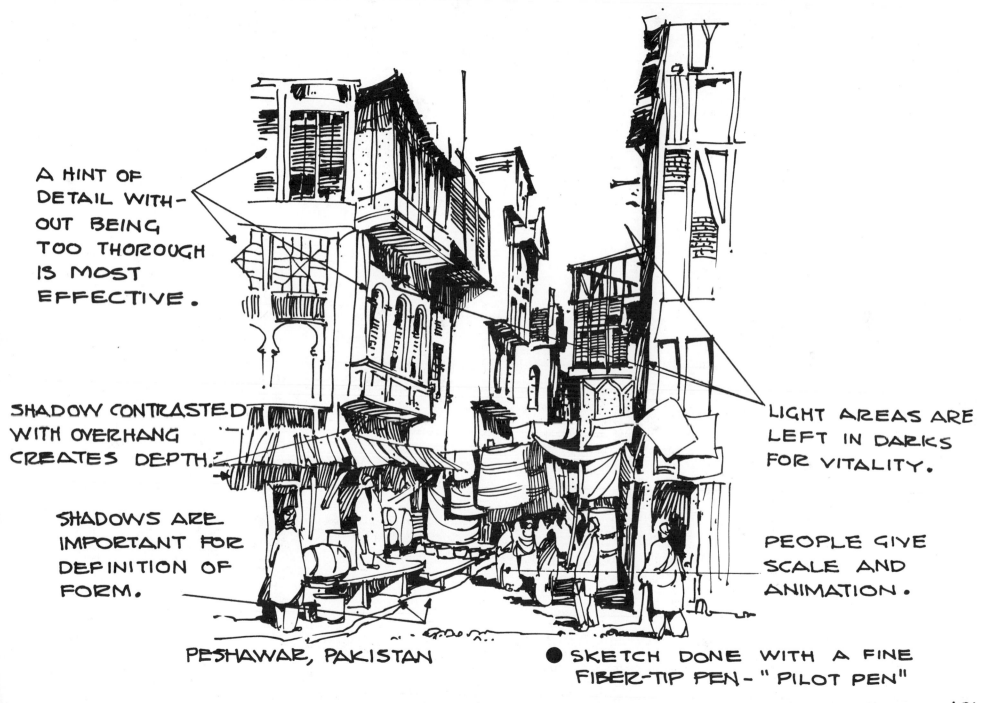

A HINT OF DETAIL WITHOUT BEING TOO THOROUGH IS MOST EFFECTIVE.

SHADOW CONTRASTED WITH OVERHANG CREATES DEPTH.

SHADOWS ARE IMPORTANT FOR DEFINITION OF FORM.

LIGHT AREAS ARE LEFT IN DARKS FOR VITALITY.

PEOPLE GIVE SCALE AND ANIMATION.

PESHAWAR, PAKISTAN

● SKETCH DONE WITH A FINE FIBER-TIP PEN - "PILOT PEN"

101

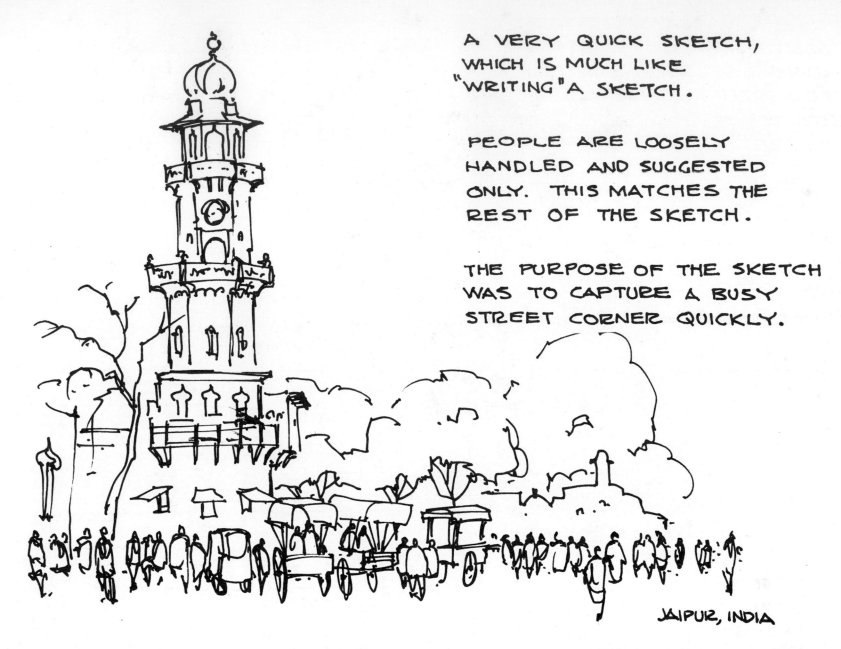

A VERY QUICK SKETCH,
WHICH IS MUCH LIKE
"WRITING" A SKETCH.

PEOPLE ARE LOOSELY
HANDLED AND SUGGESTED
ONLY. THIS MATCHES THE
REST OF THE SKETCH.

THE PURPOSE OF THE SKETCH
WAS TO CAPTURE A BUSY
STREET CORNER QUICKLY.

JAIPUR, INDIA

● SKETCH DONE WITH A FOUNTAIN PEN

TONES THROUGHOUT PLACE
DARKS AGAINST LIGHTS RE-
GARDLESS OF THE DIREC-
TION OF THE SUNLIGHT. THIS
STILL MAKES THE SKETCH
EFFECTIVE.

GROUND DARKS
ESTABLISH BASE
FOR BUILDINGS.

HIGH CONTRAST
OF FIGURES
STIMULATES
INTEREST AND
PROVIDES A
FOCAL POINT.

CONTRASTING SCALE
OF FOREGROUND AND
MIDDLE GROUND
DRAMATIZES SKETCH.

TREES AND PEOPLE FORM
THE FOREGROUND, GIVING
SCALE AND DEPTH TO THE
SKETCH.

RENDERING THE SHADOW
SIDE OF THE TREE IS
SUFFICIENT TO SUGGEST
THE ENTIRE TREE.

NOTE BROKEN
LEAF PROFILE
OF THE TREE

● SKETCH DONE WITH A
MECHANICAL PENCIL
USING 4B LEAD

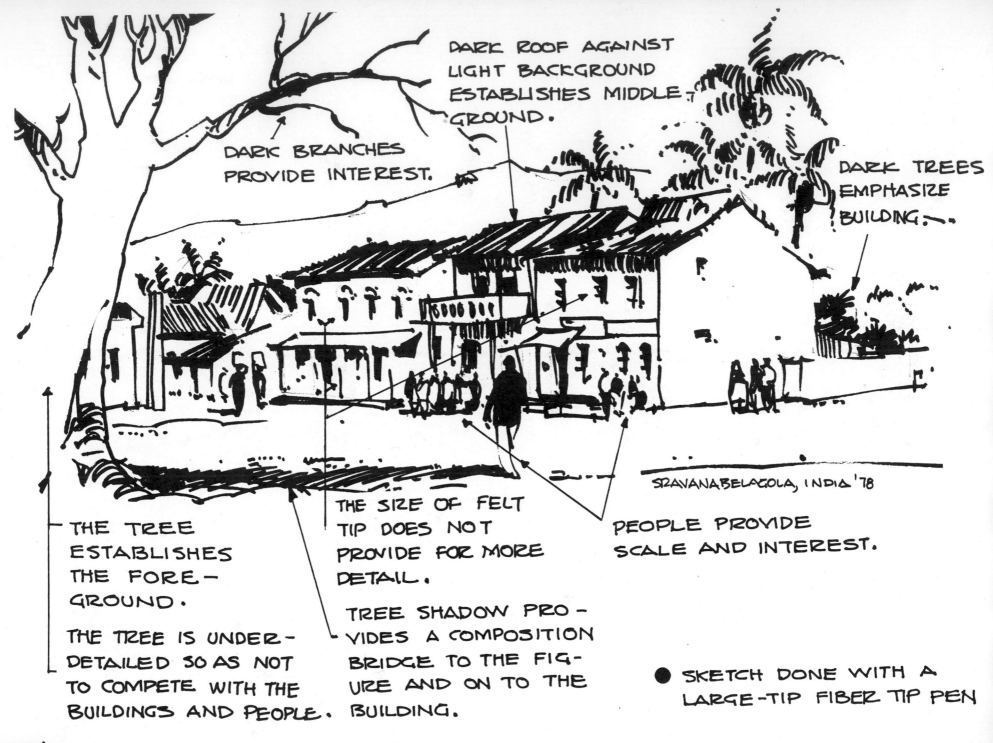

DARK ROOF AGAINST LIGHT BACKGROUND ESTABLISHES MIDDLE GROUND.

DARK BRANCHES PROVIDE INTEREST.

DARK TREES EMPHASIZE BUILDING.

SRAVANABELAGOLA, INDIA '78

THE TREE ESTABLISHES THE FORE-GROUND.

THE TREE IS UNDER-DETAILED SO AS NOT TO COMPETE WITH THE BUILDINGS AND PEOPLE.

THE SIZE OF FELT TIP DOES NOT PROVIDE FOR MORE DETAIL.

TREE SHADOW PRO-VIDES A COMPOSITION BRIDGE TO THE FIG-URE AND ON TO THE BUILDING.

PEOPLE PROVIDE SCALE AND INTEREST.

● SKETCH DONE WITH A LARGE-TIP FIBER TIP PEN

104

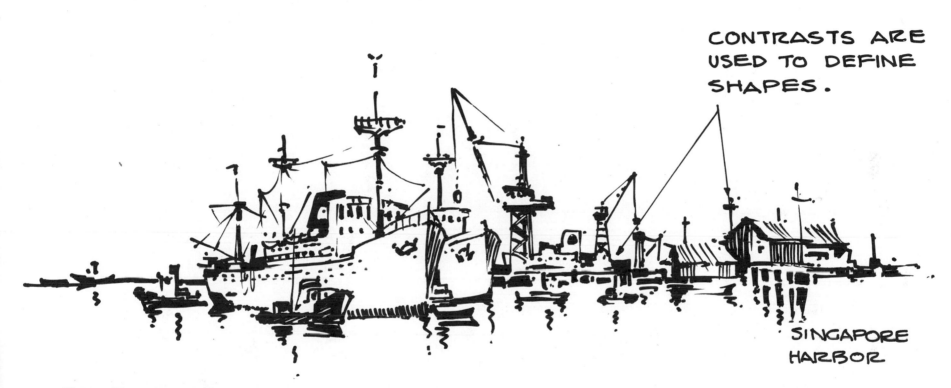

CONTRASTS ARE USED TO DEFINE SHAPES.

SINGAPORE HARBOR

TIP OF PEN PREVENTS THE SKETCH FROM BECOMING TOO DETAILED.

● SKETCH DONE WITH A #5 "SPEEDBALL" PEN

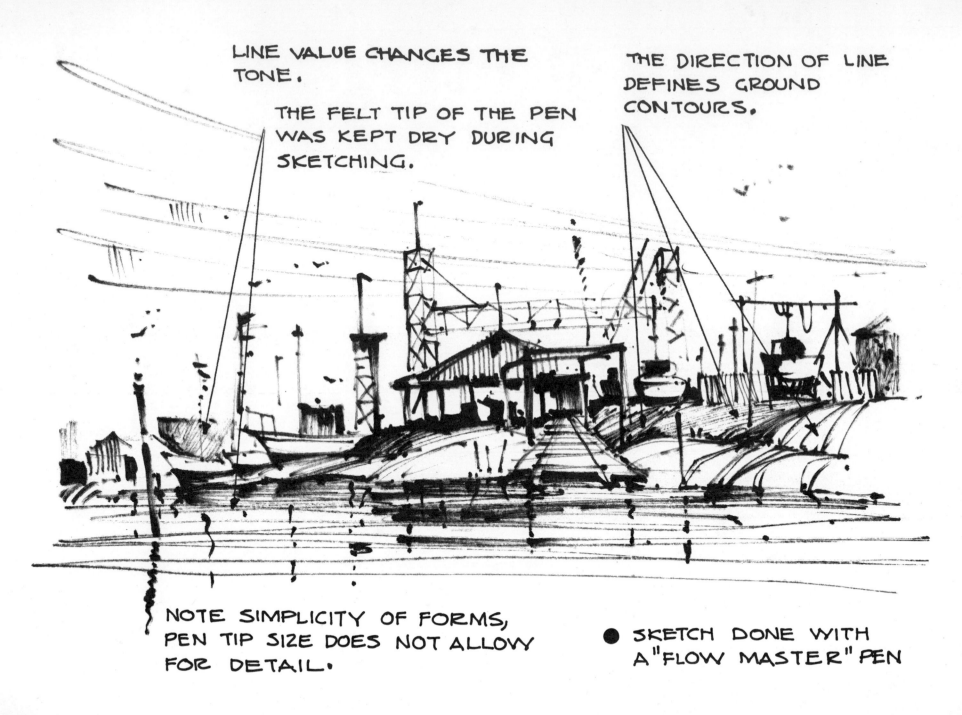

LINE VALUE CHANGES THE TONE.

THE FELT TIP OF THE PEN WAS KEPT DRY DURING SKETCHING.

THE DIRECTION OF LINE DEFINES GROUND CONTOURS.

NOTE SIMPLICITY OF FORMS, PEN TIP SIZE DOES NOT ALLOW FOR DETAIL.

● SKETCH DONE WITH A "FLOW MASTER" PEN

SKETCH PORTFOLIO

108. FIBER-TIP PEN, ON-THE-SPOT
109. BALL-POINT PEN, FINISHED WITH DILUTED INK WASH
110. BALL-POINT PEN, FINISHED WITH DILUTED INK WASH
111. MISCELLANEOUS PEN SKETCHES
112. SOFT TIP FELT PEN, ACTS LIKE A SMALL BRUSH
113. FINE TIP FIBER PEN, ON-THE-SPOT SKETCHES - ACTUAL SIZE
114. DRAFTING PEN, VALUES OF TONES AND SHADOWS DEFINE ALL-WHITE BUILDINGS
115. MEDIUM TIP FIBER PEN, ON-THE-SPOT SKETCH
116. WEDGE SHAPED FELT-TIP, DONE QUICKLY FROM A MOVING TRAIN, GOOD EXERCISE
117. MISCELLANEOUS FIGURE SKETCHES, QUICK, A MUST EXERCISE
118. CHISEL-SHAPED, FIBER-TIP PEN, ON-THE-SPOT

119. CONTÉ STICK CRAYON USED ON EDGE
120. FOUNTAIN PEN, ON-THE-SPOT
121. RECTANGULAR LEAD PENCIL
122. DRAFTING PEN, NOT A QUICK SKETCH
123. DRAFTING PEN, BLOCKED OUT ON-THE-SPOT, FINISHED LATER
124. MEDIUM TIP FIBER PEN, ON-THE-SPOT.
125. ART SKETCH PEN, ON-THE-SPOT
126. ART SKETCH PEN, ON-THE-SPOT
127. PENCIL SKETCH
128. CHISEL-TIP FELT PEN
129. GRAPHOS PEN, BALL POINT
130. GRAPHOS PEN, BARREL POINT

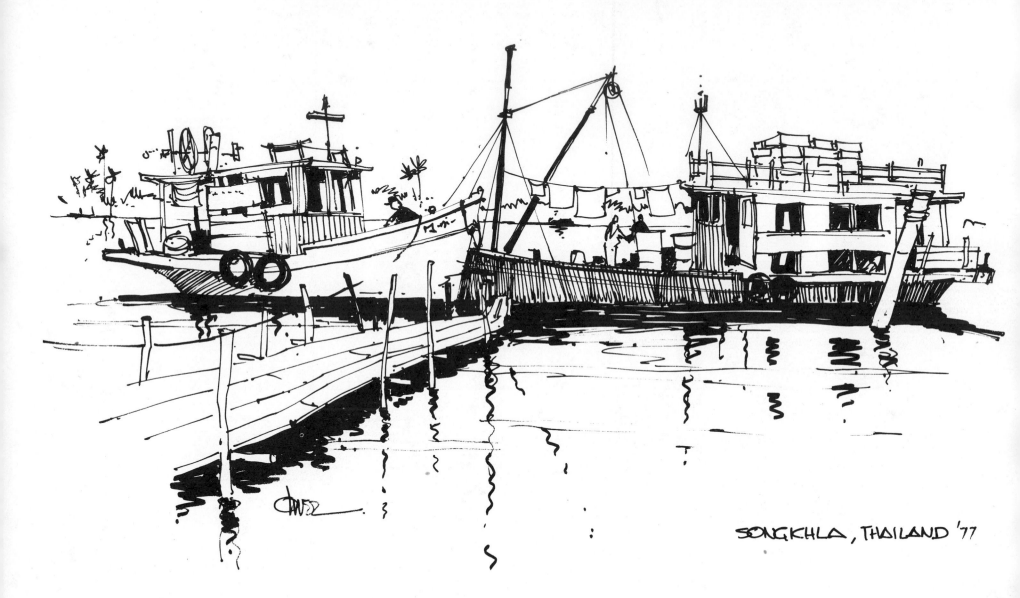

SONGKHLA, THAILAND '77

108

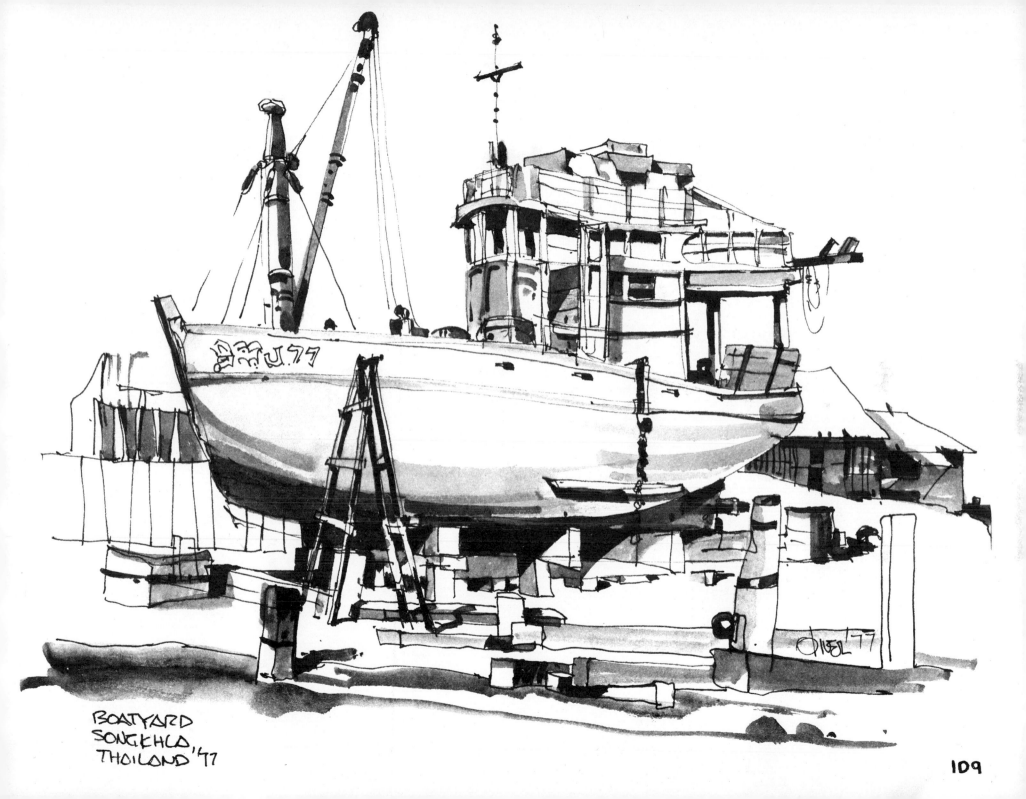

BOATYARD
SONGKHLD,
THOILAND '77

109

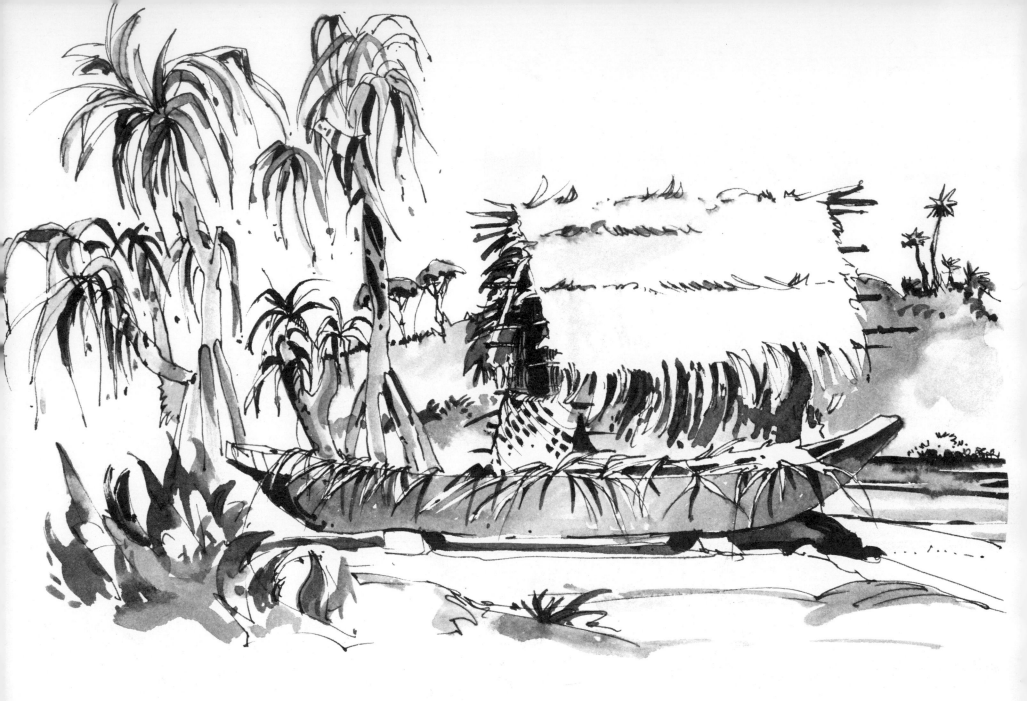

PATONG BEACH
PHUKET, THAILAND '77

110

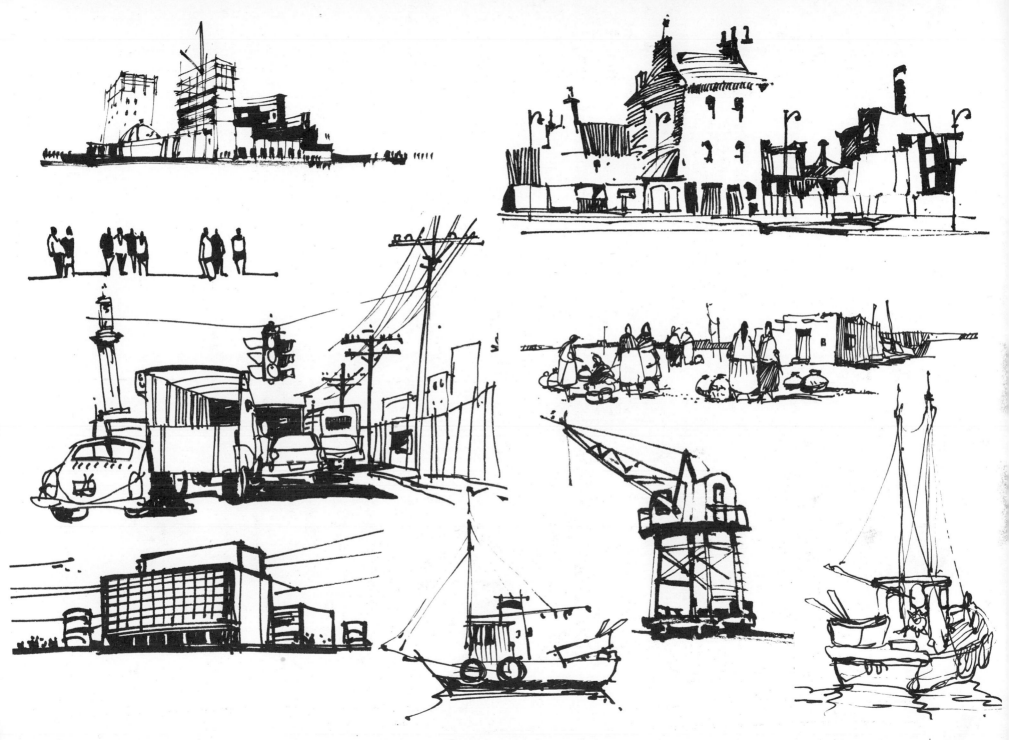

111

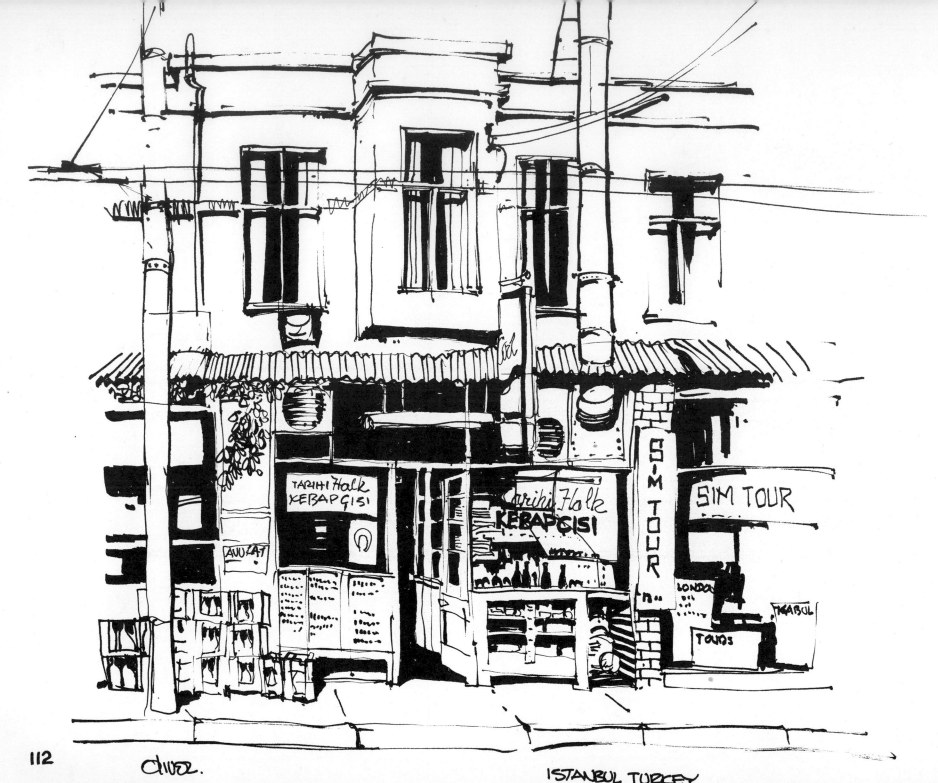

112
Clive.
ISTANBUL, TURKEY

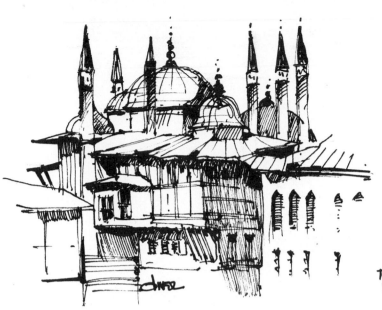

TOPKAPI PALACE HAROM
ISTANBUL, TURKEY '78

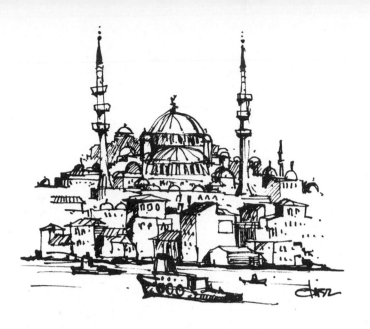

THE NEW MOSQUE
YENI CAMI
ISTANBUL, TURKEY '78

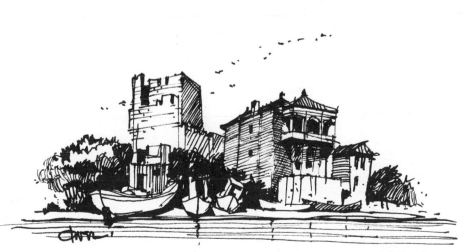

ANADOLU CASTLE
ISTANBUL,
TURKEY.

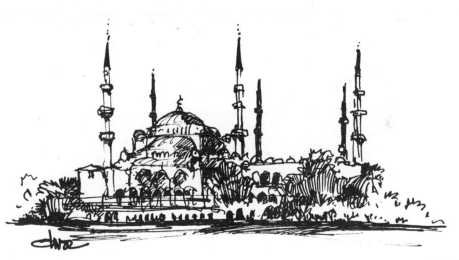

THE BLUE MOSQUE
ISTANBUL, TURKEY 78

113

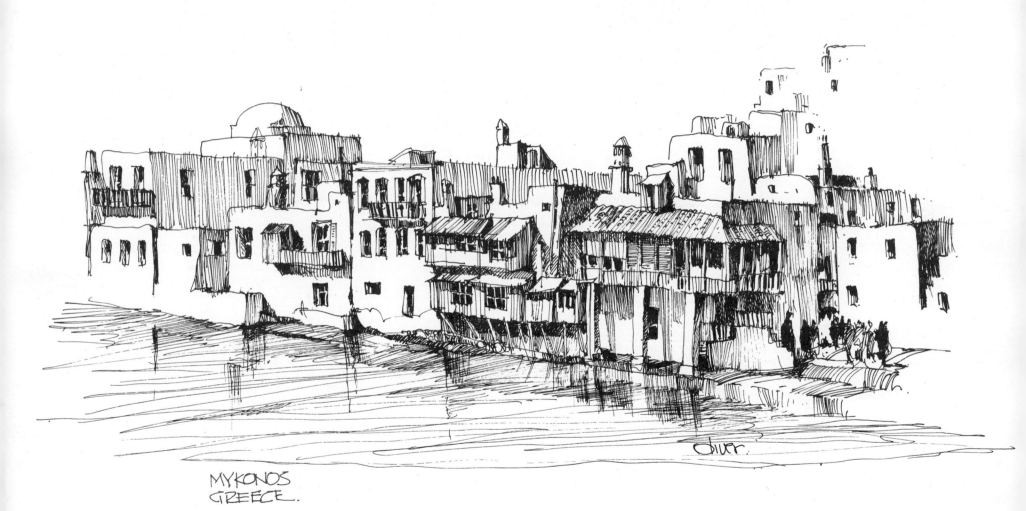

MYKONOS
GREECE.

114

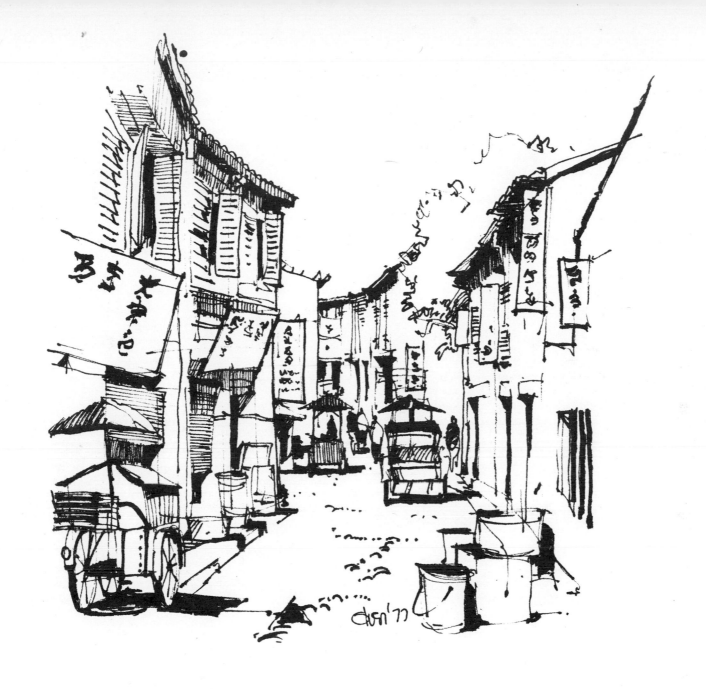

LOVE LANE
GEORGETOWN
PENANG
MALAYSIA . 77

115

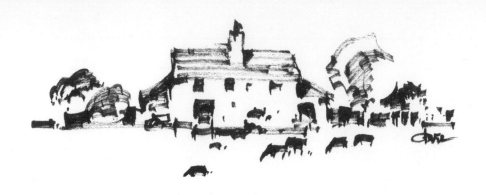

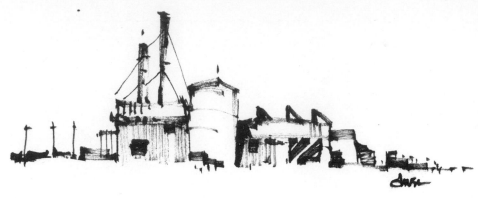

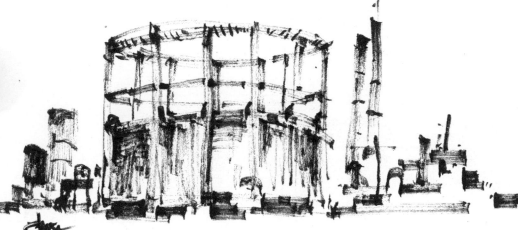

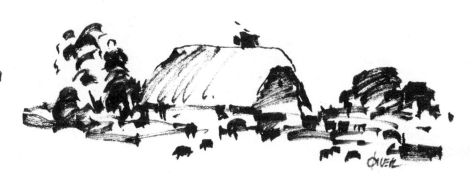

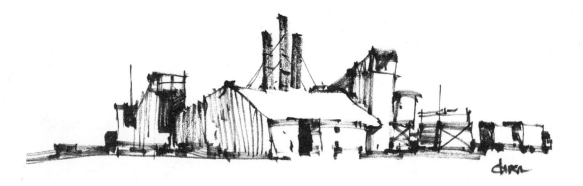

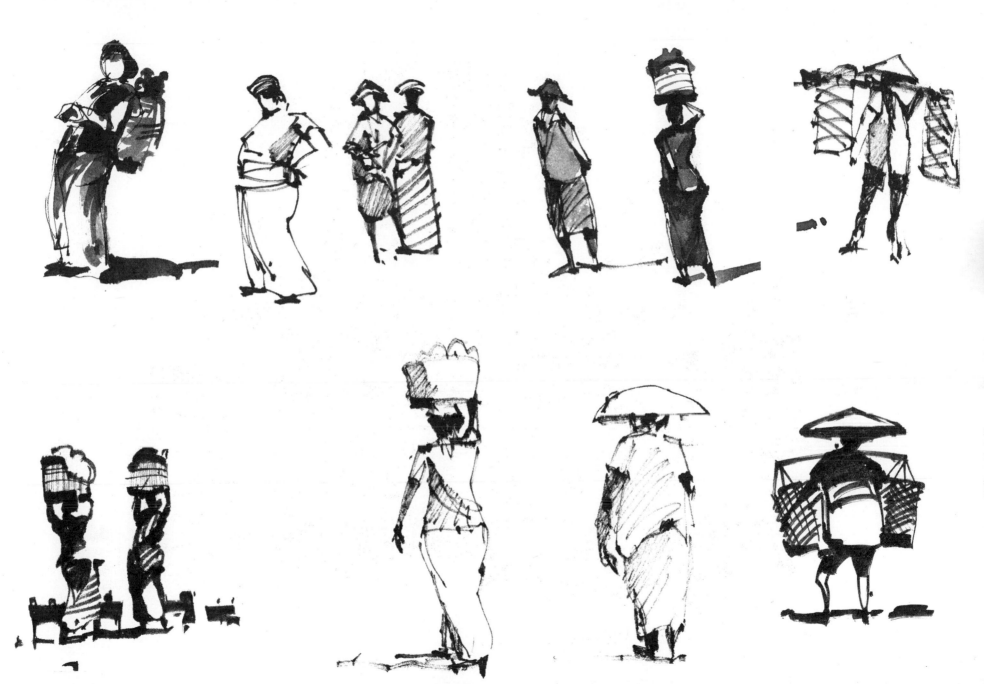

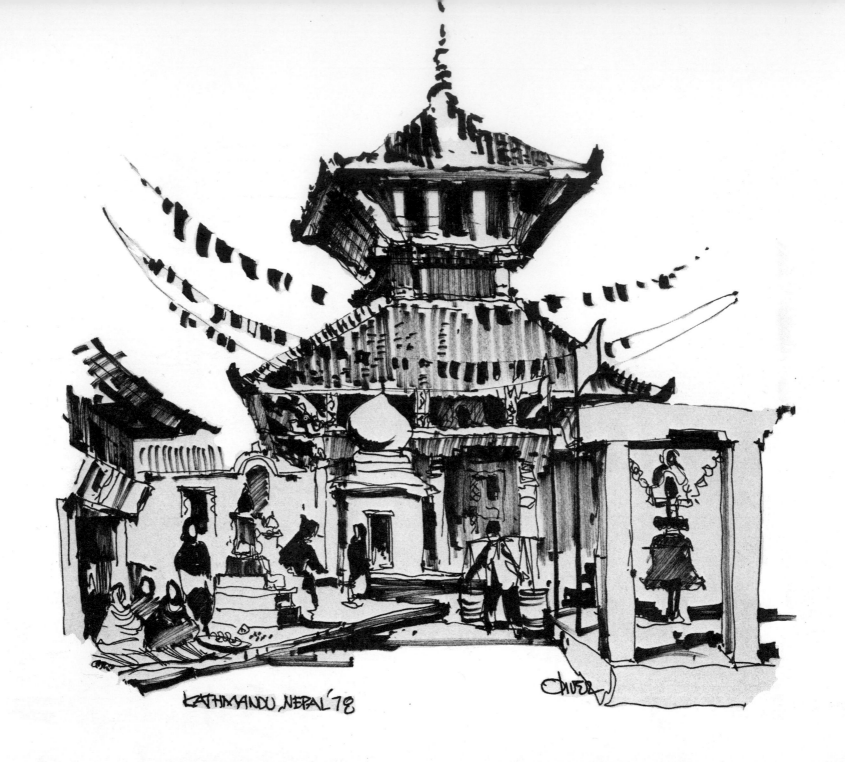

KATHMANDU, NEPAL '78

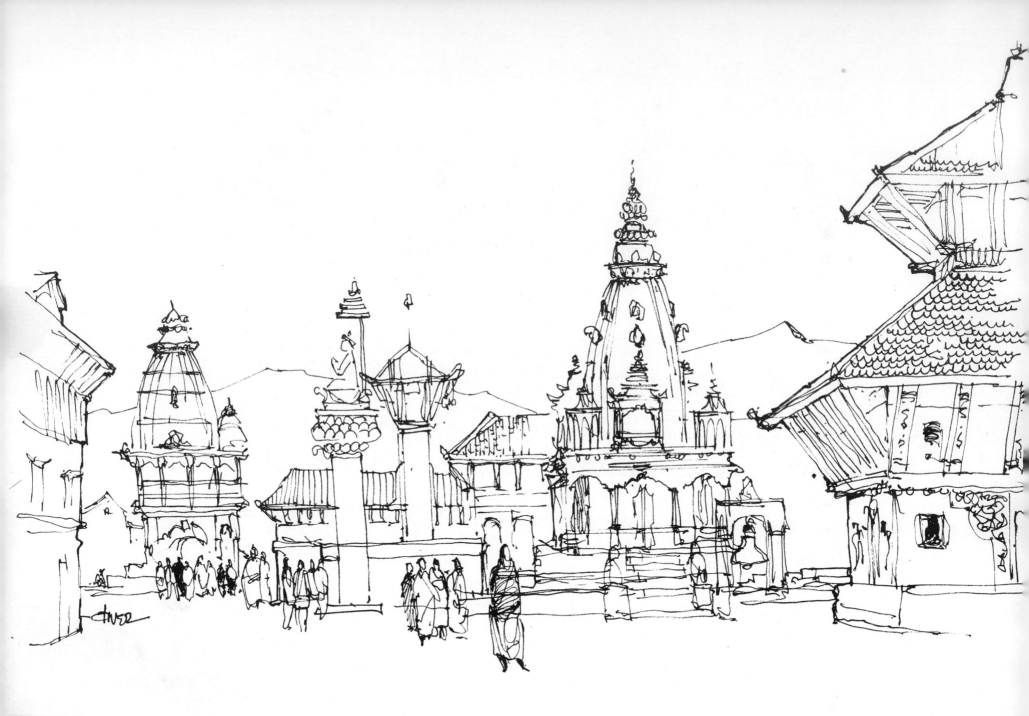

DURBAR SQUARE,
BHAKTAPUR, NEPAL '78

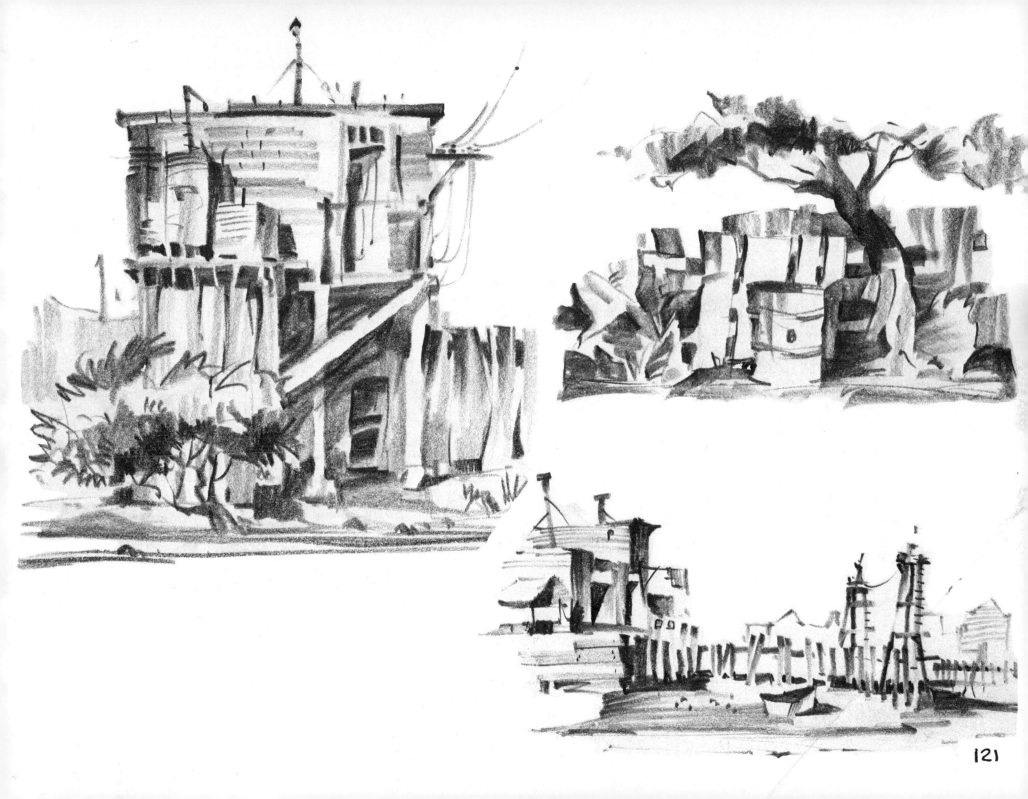

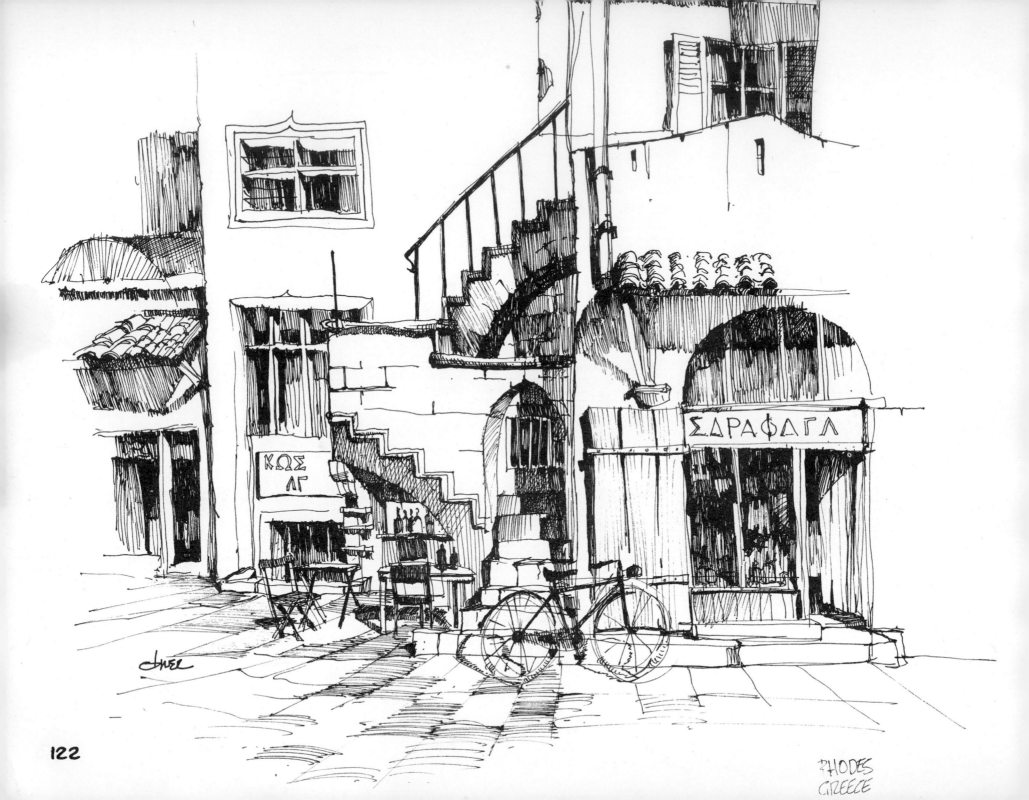

122

ΣΔΡΑΦΑΓΛ

ΚΩΣ ΛΓ

RHODES
GREECE

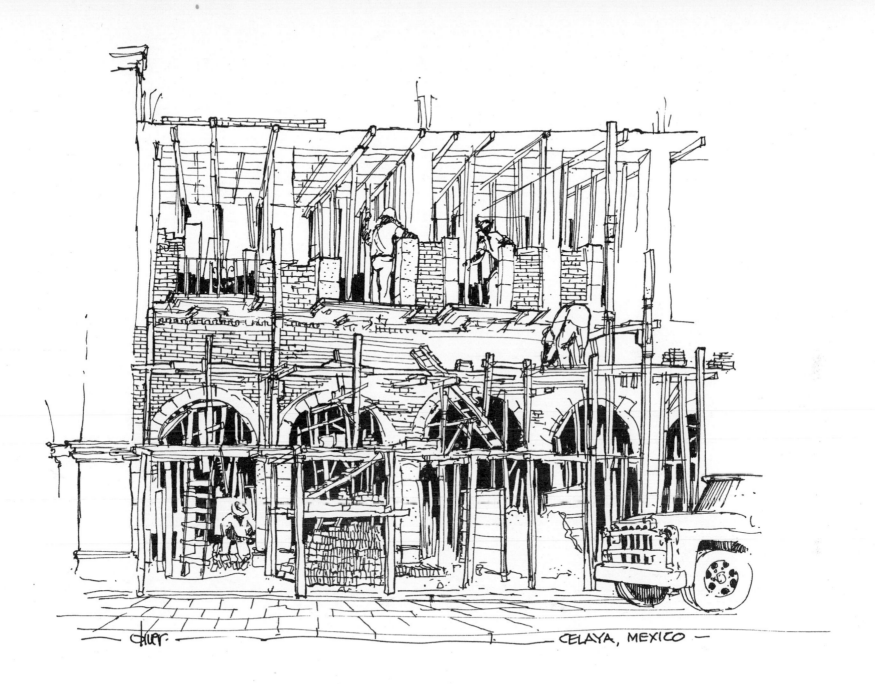

CELAYA, MEXICO

123

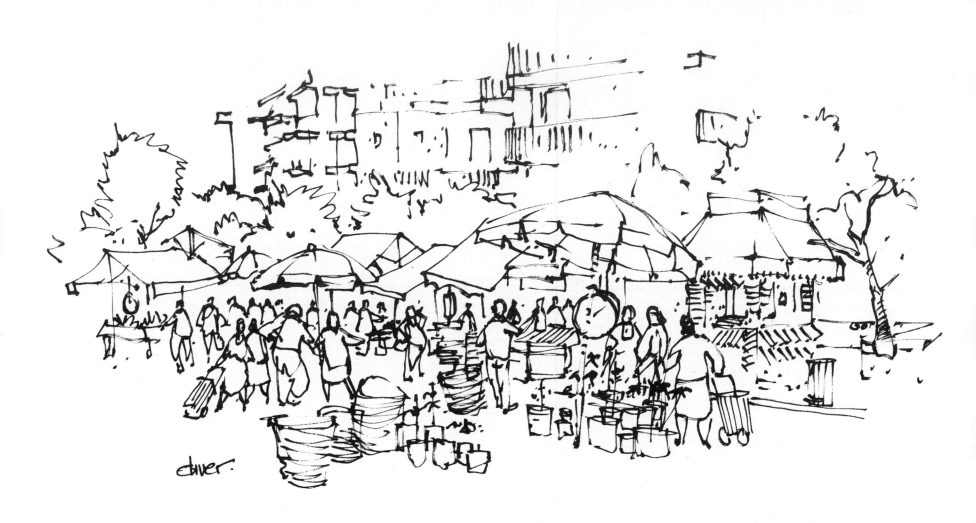

oliver.

MARKET DAY
XENOKRATEUS ST
ATHENS GREECE

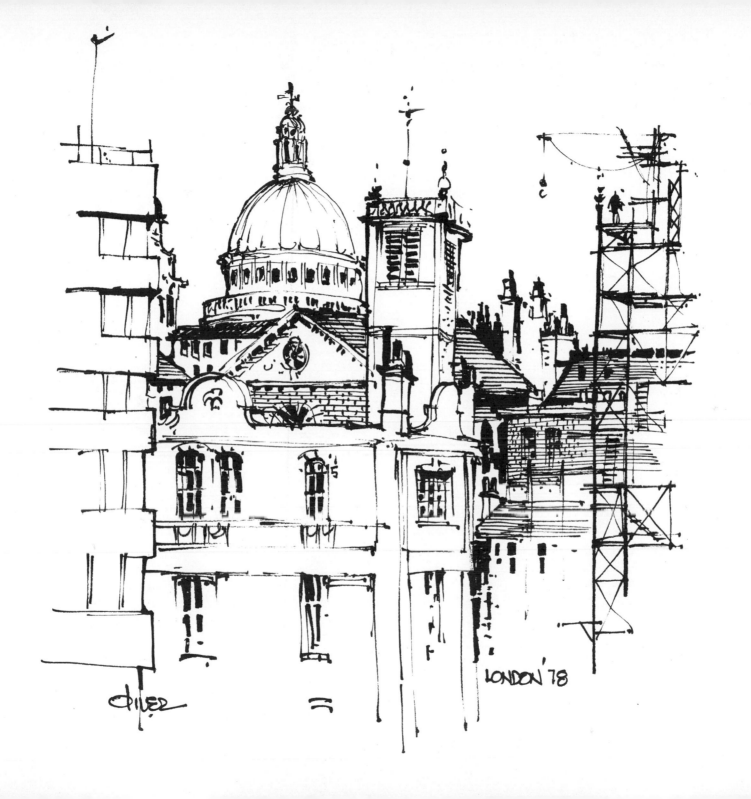

LONDON '78

125

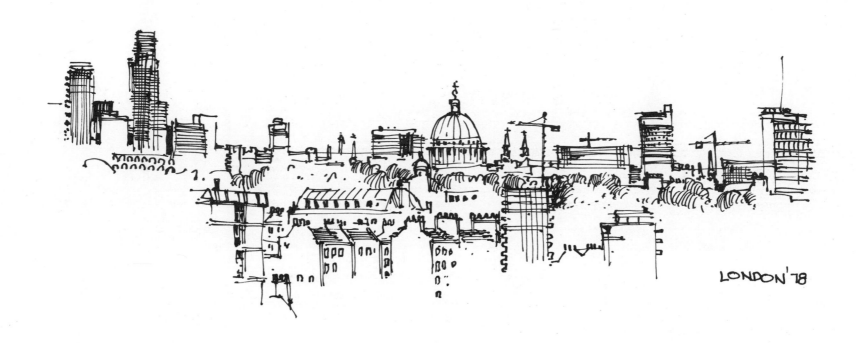

LONDON '78

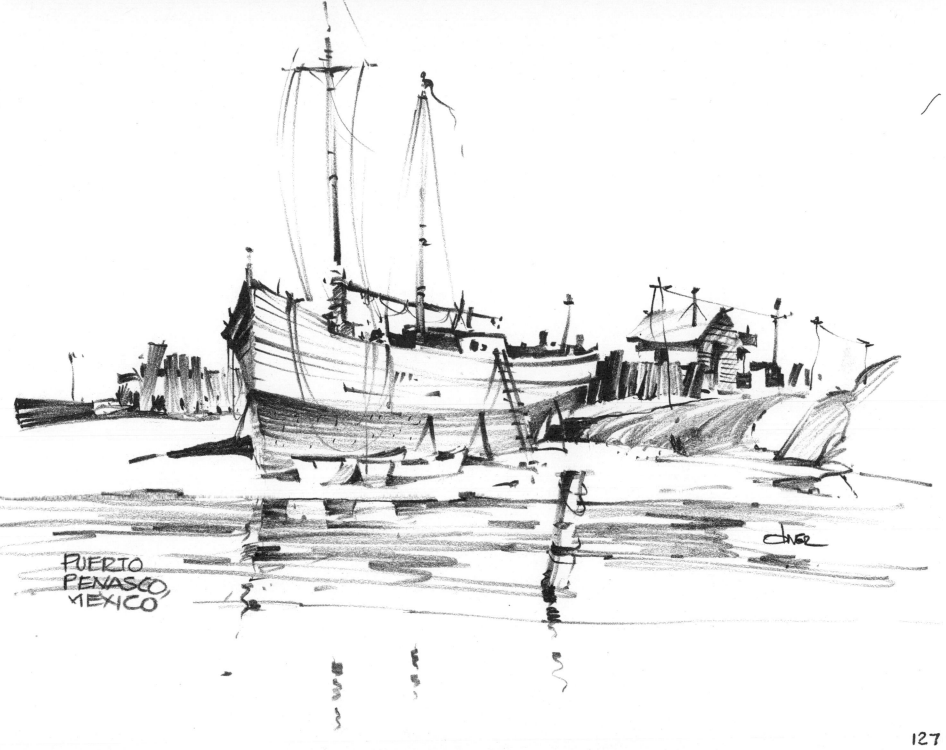

PUERTO
PENASCO,
MEXICO

127

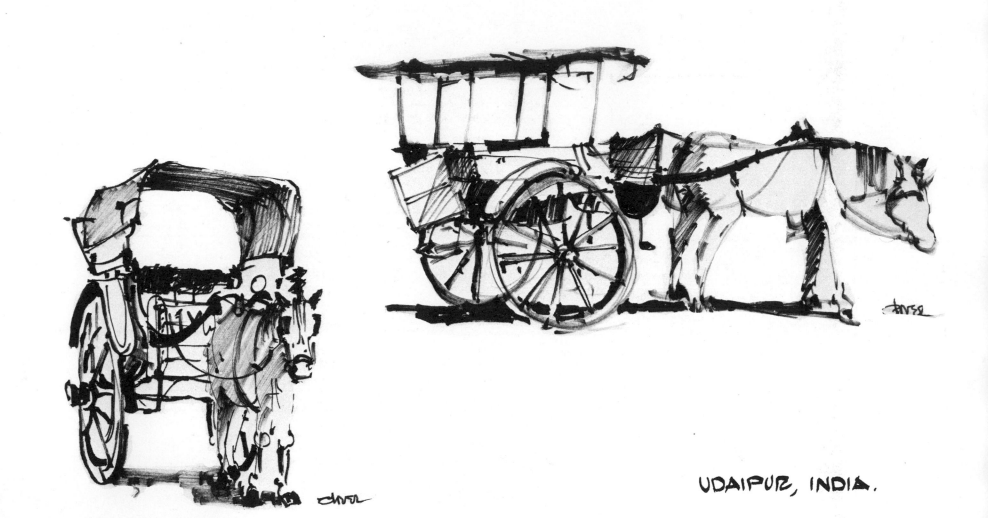

UDAIPUR, INDIA.

128

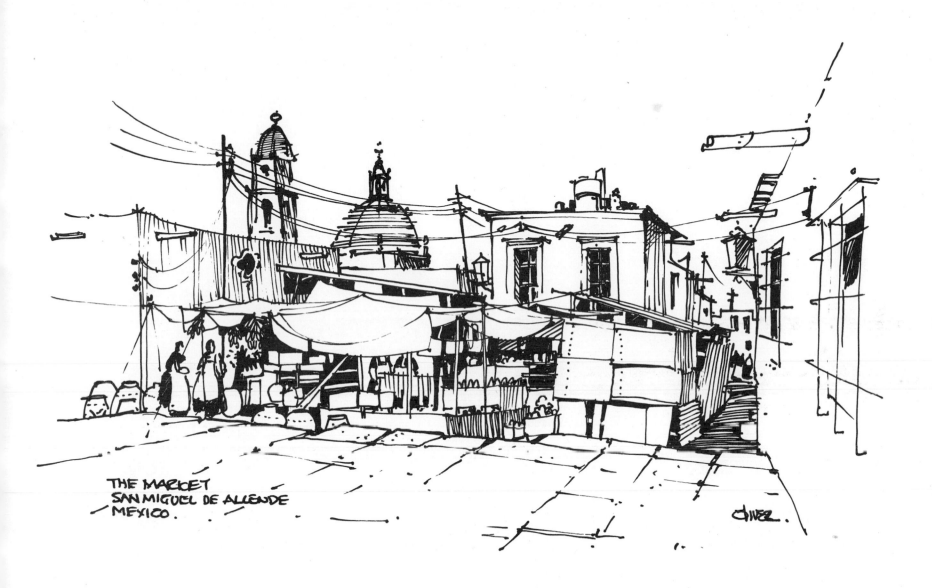

THE MARKET
SAN MIGUEL DE ALLENDE
MEXICO.

Oliver.

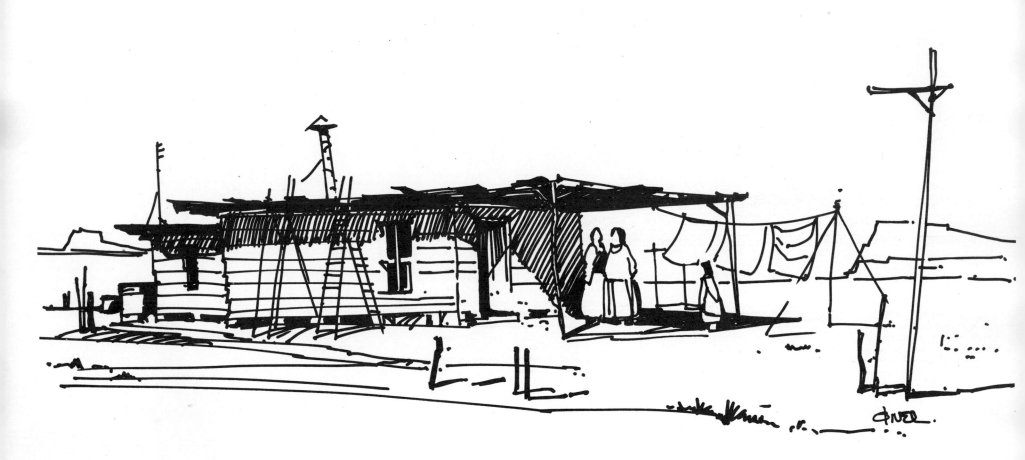

REFERENCE BOOKS

THE ART OF PENCIL DRAWING

ERNEST W. WATSON
WATSON-GUPTILL PUBLICATIONS 1975

ARCHITECTURAL GRAPHICS

FRANK CHING
VAN NOSTRAND REINHOLD CO. 1975

ARTIST ON THE SPOT

NORMAN MACDONALD
VAN NOSTRAND REINHOLD CO. 1972

CREATIVE PENCIL DRAWING

PAUL HOGARTH
VAN NOSTRAND REINHOLD CO. 1970

COURSE IN PENCIL SKETCHING

ERNEST W. WATSON
VAN NOSTRAND REINHOLD CO. 1978

CREATIVE INK DRAWING

PAUL HOGARTH
VAN NOSTRAND REINHOLD CO. 1974

ON-THE-SPOT DRAWING

NICK MEGLIN
WATSON-GUPTILL PUBLICATIONS 1968

PENCIL SKETCHING

THOMAS C. WANG
VAN NOSTRAND REINHOLD CO. 1977

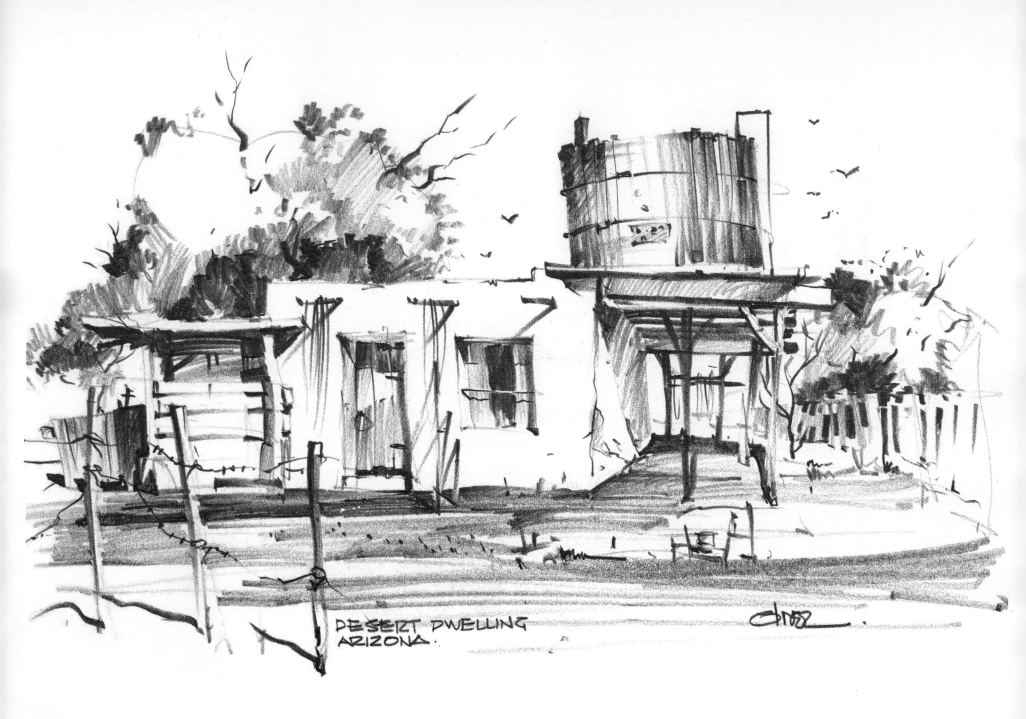

DESERT DWELLING
ARIZONA.

132

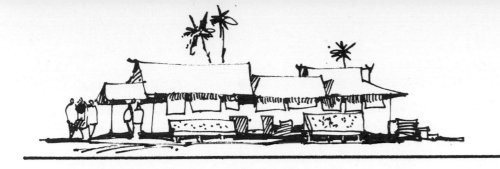

INDEX